CATS
HOW TO DRAW T

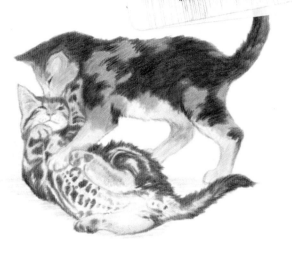

To my daughter Sara,
whose idea for me to draw more cats
eventually led to this book.

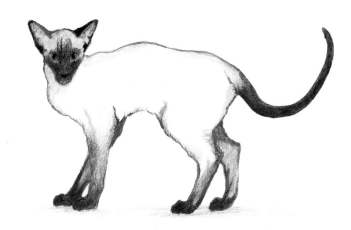

CATS
HOW TO DRAW THEM

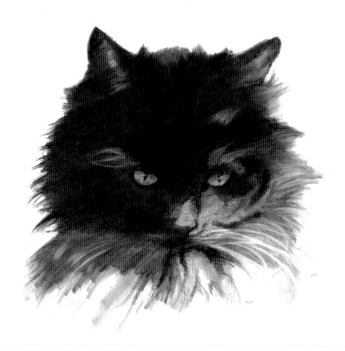

MELVYN PETTERSON

NORTH LIGHT BOOKS
Cincinnati, Ohio

First published in Great Britain in 2001 by
Collins & Brown Limited
London House
Great Eastern Wharf
Parkgate Road
London SW11 4NQ

First published in North America
in 2001 by North Light Books
an imprint of F&W Publications, Inc.
1507 Dana Avenue
Cincinnati, OH 45207
1-800/289-0963

Illustrations by Melvyn Petterson
Edited by Ian Kearey
Designed by Alison Shackleton
Photography by George Taylor

1 3 5 7 9 8 6 4 2

Reproduction by Classicscan Pte. Ltd, Singapore
Printed and bound by Tat Wei Printing Packaging Pte Ltd, Singapore

ISBN 1-58180-197-1

Library of Congress Cataloging-in-Publication Data Is Available.

CONTENTS

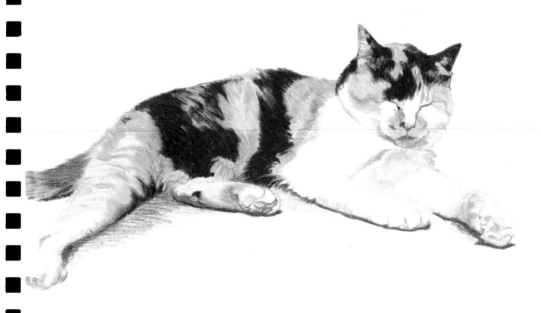

BASIC SHAPES

Before you begin to draw cats with any accuracy, you need to understand how their skeletons and muscles form the framework for what we see. This chapter looks at cat proportions and at the two basic body shapes found in domestic cats – slim and stocky.

Cat Shapes

Part of the dictionary definition of 'cat' is 'an agile, partly nocturnal, quadrupedal carnivorous mammal, *Felis catus*, with retractable claws'. The other thing common to all members of the extended cat family – from lions and tigers to house cats – is the shape and anatomy, which provide a cat with its characteristic and unique flexibility and strength.

It's worth taking some time to study what lies beneath the fur, as the arrangement of bones and muscles is what allows

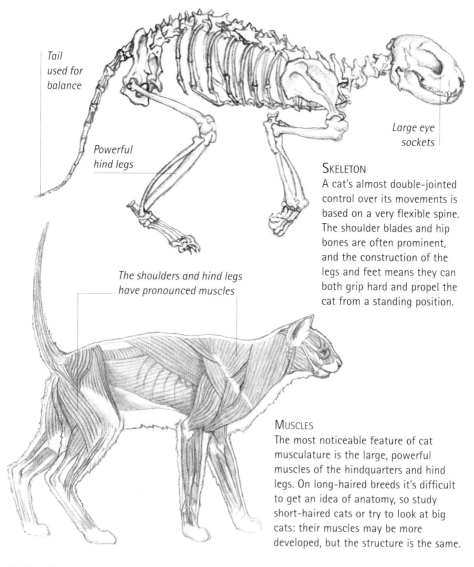

Tail used for balance

Powerful hind legs

Large eye sockets

The shoulders and hind legs have pronounced muscles

Skeleton
A cat's almost double-jointed control over its movements is based on a very flexible spine. The shoulder blades and hip bones are often prominent, and the construction of the legs and feet means they can both grip hard and propel the cat from a standing position.

Muscles
The most noticeable feature of cat musculature is the large, powerful muscles of the hindquarters and hind legs. On long-haired breeds it's difficult to get an idea of anatomy, so study short-haired cats or try to look at big cats: their muscles may be more developed, but the structure is the same.

cats to adopt their most characteristic poses: curled round, at full stretch, or crouched while stalking, for example.

This is particularly true if, like most artists who draw cats, you make some use of reference photographs or have to rely on putting together a single composite drawing from a number of quick sketches. The bottom line is that the more you observe and come to understand what physically makes up a cat, the better you will be able to set it down on paper.

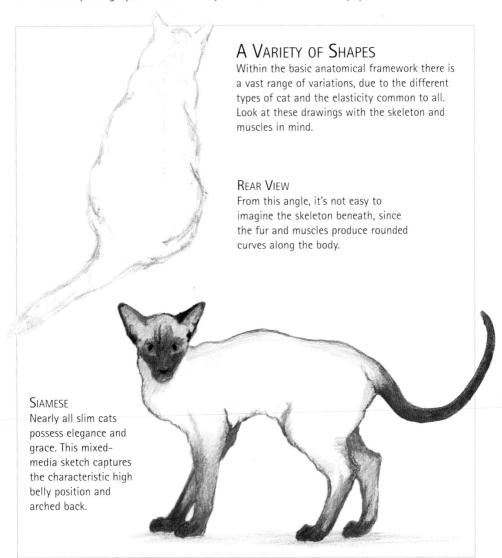

A Variety of Shapes

Within the basic anatomical framework there is a vast range of variations, due to the different types of cat and the elasticity common to all. Look at these drawings with the skeleton and muscles in mind.

Rear View

From this angle, it's not easy to imagine the skeleton beneath, since the fur and muscles produce rounded curves along the body.

Siamese

Nearly all slim cats possess elegance and grace. This mixed-media sketch captures the characteristic high belly position and arched back.

Body Size

The sheer variety of cat breeds makes it almost impossible to define a standard cat shape and size. The size and proportions of a slim, attenuated Siamese will differ considerably from a large Maine Coon, for example. Look at your cat as an individual and note the relative size of its key features – the head, body, tail and legs. Think about the underlying structure and also about the thickness of the fur – a long-coated cat will appear larger than its short-coated equivalent. The age of your cat will also determine the size of its features.

Standing or walking poses show the relation of the key features most clearly, but be ready for these to alter in other poses – sitting and lying down both produce great changes and demand patient observation.

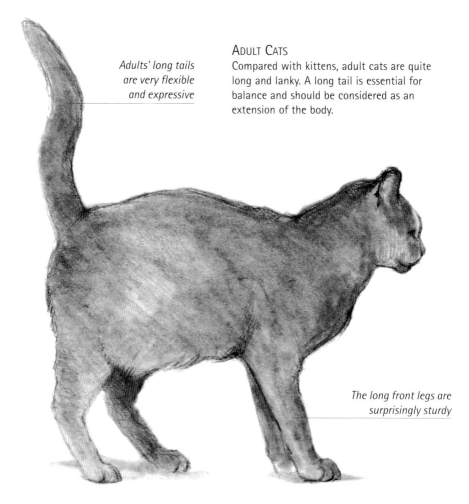

Adults' long tails are very flexible and expressive

Adult Cats
Compared with kittens, adult cats are quite long and lanky. A long tail is essential for balance and should be considered as an extension of the body.

The long front legs are surprisingly sturdy

Head Proportions

The features of the head and face also vary between breeds. Judge the position of the eyes, nose and mouth by observing the whole head (see pages 22–27) and consider the length of the neck.

Adult Head
In adults, the positions of the ears, eyes, nose and mouth are regularly balanced within the overall size of the head. The neck is relatively long.

Kitten Head
Kittens' eyes are disproportionately large, while the ears, nose and mouth are more in keeping with the head size. The neck is barely discernible.

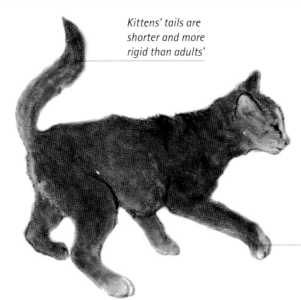

Kittens' tails are shorter and more rigid than adults'

Kittens' paws are often large in proportion to their short legs

Kittens
At first glance, a kitten may appear to be just a scaled-down version of an adult cat, but if you draw it as such, the result will be disappointing. Look at the proportionally rounder chest, larger head and wider-set legs to begin with, then observe and put down the other, subtler differences.

SLIM CATS

Cats can be divided into two groups, according to their body shape. The term slim cats encompasses most of what are called the 'exotic' breeds – Siamese and Abyssinian are the longest established in the West, Siamese being imported since the nineteenth century, although newer breeds, such as Singapura and Balinese, have become increasingly popular with the public.

What distinguishes cats in this group is slender bodies, often longer than the average, arched backs, long legs and tails, and long muzzles and noses; the ears may also be larger than in other breeds.

The challenge of capturing slim cats on paper is an exciting one, for both their colouring and their shapes and proportions. The next chapter, 'Aspects of Cats', concentrates on setting down the details of stocky cats because they are numerically the most likely to be owned or encountered, but exactly the same rules of observation apply when dealing with slim cats. Perhaps this is even more the case, since the attenuated poses slim cats strike can be all too easily exaggerated or diminished by the artist making assumptions about what is there, rather than by actually looking.

WATCHFUL SIAMESE
In some poses slim cats seem to be nothing but a set of angles – here, the body rises to make a triangle at the top, while the bottom edge is broken by the hind paw and tail. The long head makes an inverted triangle in the middle of the composition.

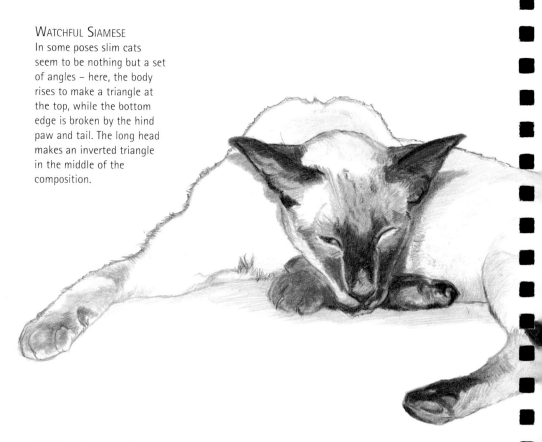

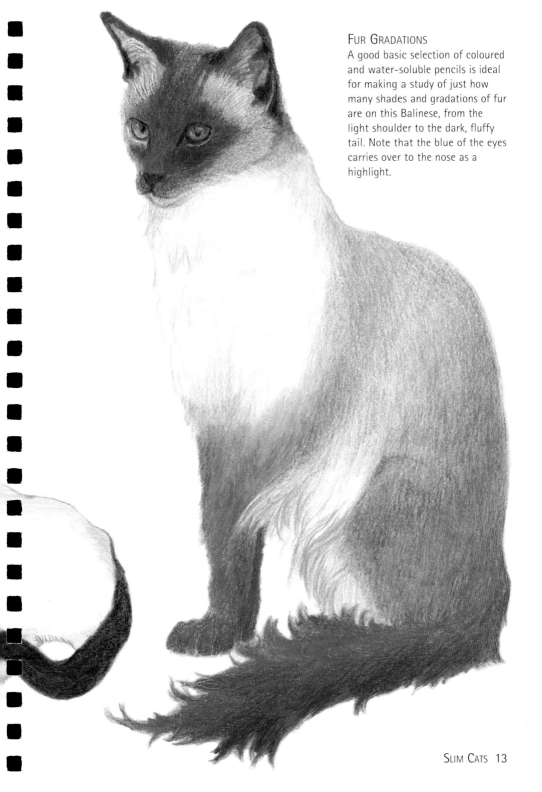

FUR GRADATIONS

A good basic selection of coloured and water-soluble pencils is ideal for making a study of just how many shades and gradations of fur are on this Balinese, from the light shoulder to the dark, fluffy tail. Note that the blue of the eyes carries over to the nose as a highlight.

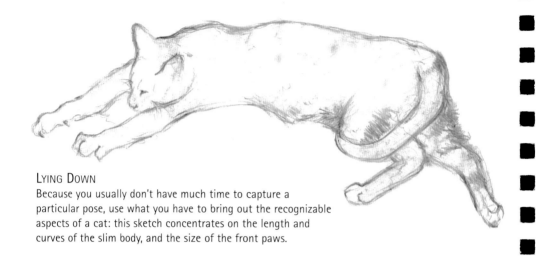

LYING DOWN

Because you usually don't have much time to capture a particular pose, use what you have to bring out the recognizable aspects of a cat: this sketch concentrates on the length and curves of the slim body, and the size of the front paws.

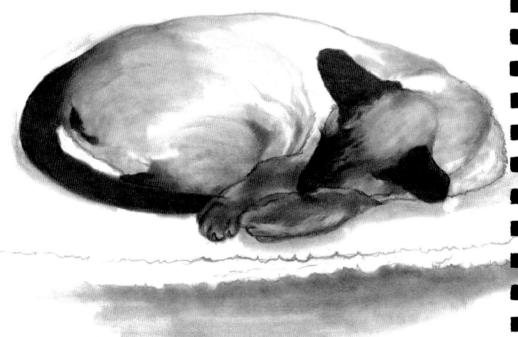

WORKING IN MONOCHROME

Black-and-white media help you to simplify your approach, and at the same time expand your repertoire. Soft graphite sticks combine well with graphite powder, blended with a torchon or finger, to catch the sweep of the tail and create contours on the legs and head.

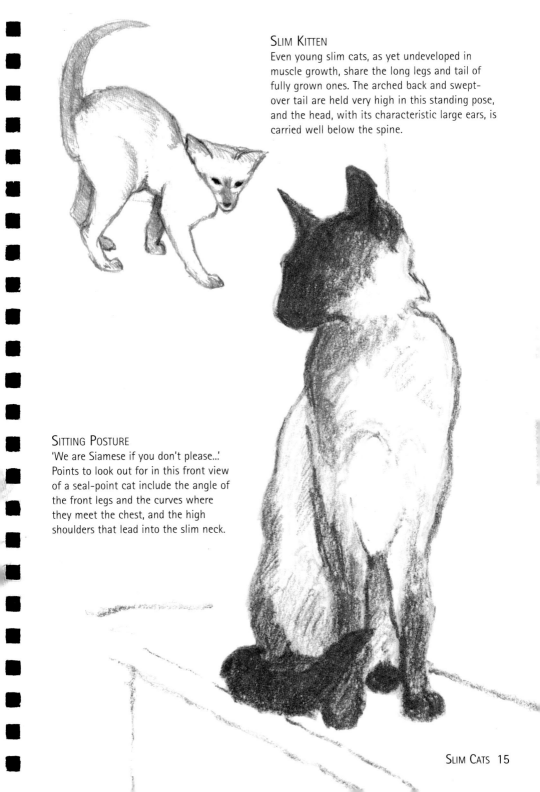

Slim Kitten
Even young slim cats, as yet undeveloped in
muscle growth, share the long legs and tail of
fully grown ones. The arched back and swept-
over tail are held very high in this standing pose,
and the head, with its characteristic large ears, is
carried well below the spine.

Sitting Posture
'We are Siamese if you don't please...'
Points to look out for in this front view
of a seal-point cat include the angle of
the front legs and the curves where
they meet the chest, and the high
shoulders that lead into the slim neck.

Stocky Cats

The most common body shape among domestic cats is the stocky. The basic shape includes everything from pedigree and highly expensive breeds of self-coloured and perfectly marked cats, through large American breeds such as ragdoll and Maine Coon, to the enormous variety of most house cats. Even within this large class there are some unusual variations, such as the tailless Manx and curly-haired Cornish Rex, not to mention the virtually furless Sphynx cats.

Stocky cats differ from slim cats in that they all have a shorter body and leg length and a rounder head and flatter face. Most long-haired breeds are stocky, so always look for the basic shape underneath the fur, as the coat can produce some unusual shapes!

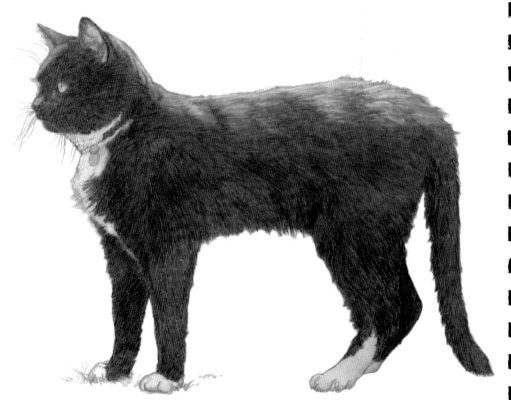

Stocky Shape
A standing profile view gives you the best opportunity to capture the details of what makes a stocky cat. Note the protruding breastbone (the front edge of the ribcage), the comparatively short neck, and the sturdy legs and paws. In this pose the shoulder blades are almost invisible.

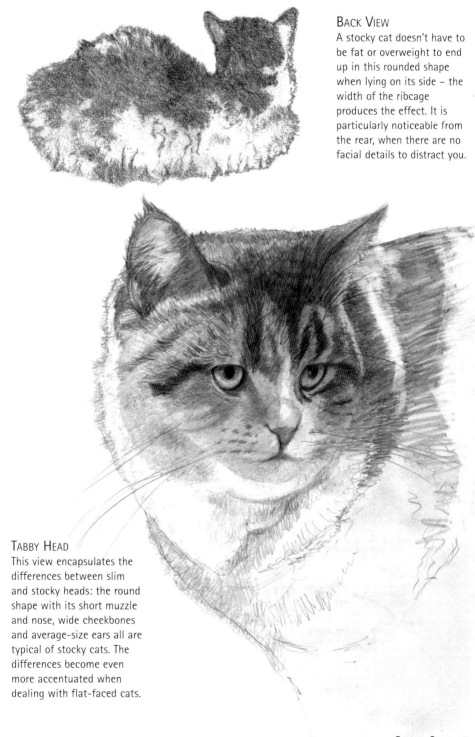

BACK VIEW
A stocky cat doesn't have to be fat or overweight to end up in this rounded shape when lying on its side – the width of the ribcage produces the effect. It is particularly noticeable from the rear, when there are no facial details to distract you.

TABBY HEAD
This view encapsulates the differences between slim and stocky heads: the round shape with its short muzzle and nose, wide cheekbones and average-size ears all are typical of stocky cats. The differences become even more accentuated when dealing with flat-faced cats.

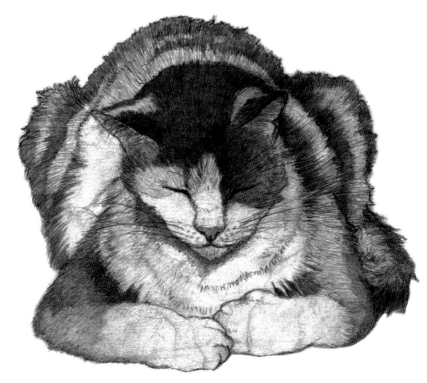

HEAD-ON VIEW

Like the other drawings on this spread, this was made of a sleeping cat, when you have the possibility of producing a reasonably finished picture. The impression of width is brought about by the large front paws, the position of the hind legs, set on either side of the hips, and the markings that go across the body.

HEAD DOWN

You don't need to see the whole head to know that this is a stocky. Even when half-hidden, the shortness of the nose and its distance from the eyes are a giveaway. Work carefully to capture the correct angle of the dark ear; look at the contrast between this and the other ear, which blends into the paw.

FUR LENGTH

Most slim cats have very short, smooth fur, so your main focus will be on getting the colour right. Stocky cats, however, have fur of varying length, which adds interest to your drawing. The differing length of fur along the top and bottom of this black-and-white cat make for a compete study of their own.

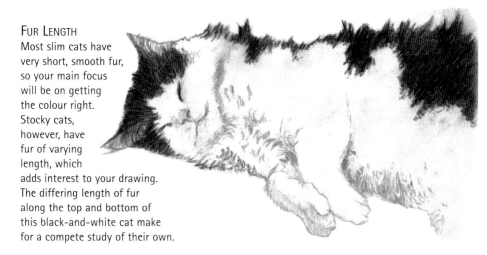

BUNCHED UP

In terms of outline, this is an exercise in a series of different-size curves – the back, head, chest and paw – interrupted only by the angular ears. In stocky cats particularly, the amazing flexibility of the spine produces this effect, where a sitting cat appears to be only about two-thirds the length of a standing one.

STRETCHED OUT

Even though stocky cats' legs are not as long as those of slim cats, they are still very prominent in a completely relaxed cat. When this cat is standing, the tail appears to be longer than the hind legs, but when the legs are stretched out the tail looks shorter.

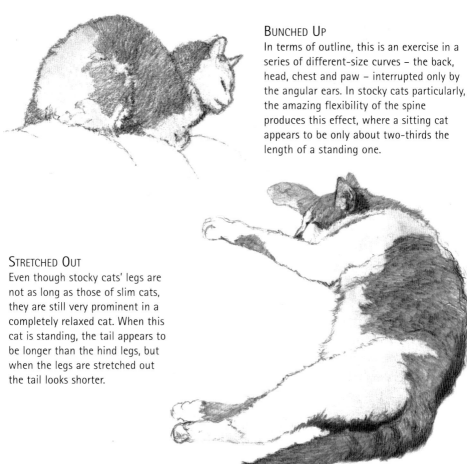

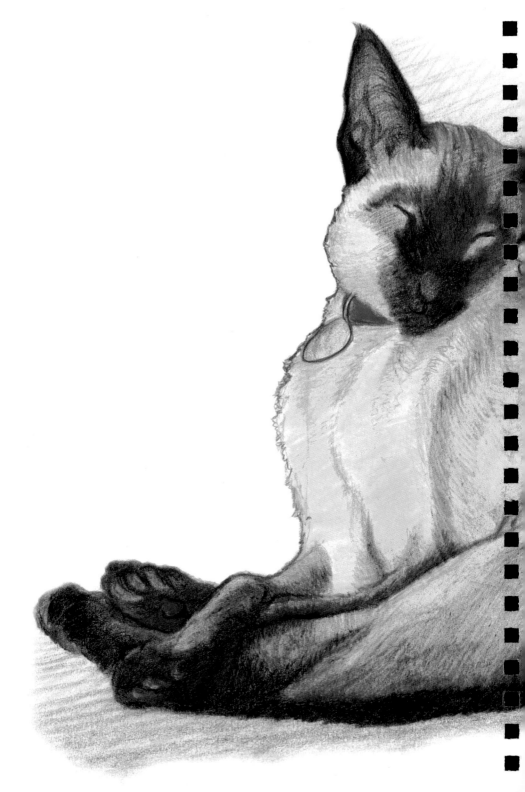

ASPECTS OF CATS

This chapter examines the elements that often cause beginners to lose confidence: the details of the head and face, and the subtlety of the paws and tail. The step-by-step projects focus on sketching the eyes, nose, mouth and ears and build up to perfectly capturing the whole head.

Heads

To start with a generalization, cats' skulls are round and their faces are, for the most part, flat. The features common to all cats are their huge, forward-facing eye sockets and wide cheekbones, which can be very protruding. The short muzzles of a cat are another distinguishing feature. Even the muzzle of slim cats, the longest of all domestic cats, is only about one-third the length of that of the average dog.

LONG-HAIRED HEAD
This drawing emphasizes the softness and length of the fur – a soft-grade pencil or a soft medium like charcoal or pastel is ideal for producing this effect. The eyes and ears appear to be quite small set against the size of the whole head, and the head and ruff hair blend together.

SHORT-HAIRED HEAD
A comparatively hard-grade pencil allows you to capture the short fur texture and strong markings of a tabby. If the ears are very large, they can become the first focus of the drawing and enable you to concentrate on setting down the delicate hairs inside them. At this distance and from this view, cats often appear to have a slight squint.

The ears can range from large and wide-set to comparatively small and close-set, but there are likely to be variations, with large and close-set a well-known combination. Again, there are many eye shapes and sizes, and their prominence can be linked to the angle from which they are viewed. The necks can be long and slender, or seem to disappear when the cat is bunched up. The following pages show some of the range.

CAPTURING HEAD SHAPES

As with any object, the basic shape of a cat's head appears to change with every marginal difference in the angle from which you view it. This is most marked in slim cats, but even stocky cats show the changes.

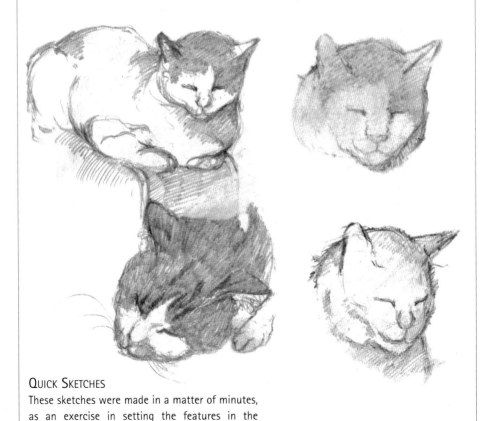

QUICK SKETCHES

These sketches were made in a matter of minutes, as an exercise in setting the features in the context of the shape of the whole head.

HEAD AND NECK

You would hardly know that this cat's head was round and that it had a neck from this view! There is a kind of monolithic quality in this pose, and it is vital to catch it by drawing from observation rather than assumptions.

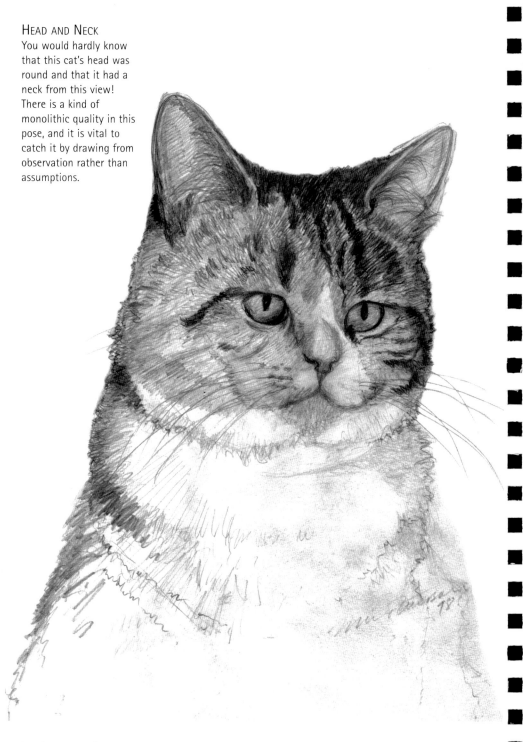

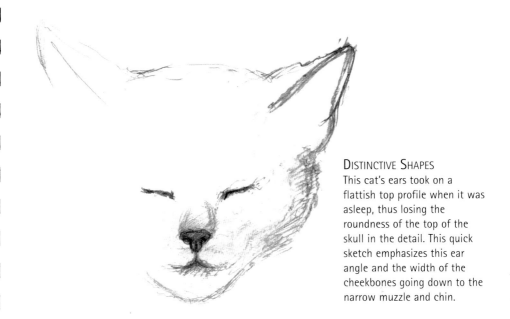

DISTINCTIVE SHAPES
This cat's ears took on a flattish top profile when it was asleep, thus losing the roundness of the top of the skull in the detail. This quick sketch emphasizes this ear angle and the width of the cheekbones going down to the narrow muzzle and chin.

UNUSUAL ANGLES
Once you get away from profile, full-face and three-quarter views, you have to bring out the character without recourse to the features. A cat on its back, viewed from below the chin, becomes an exercise in pure form. In the right-hand sketch, note the kink in the ear where it is bent by the ground.

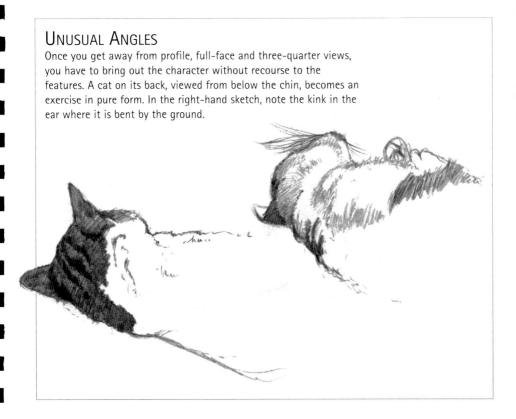

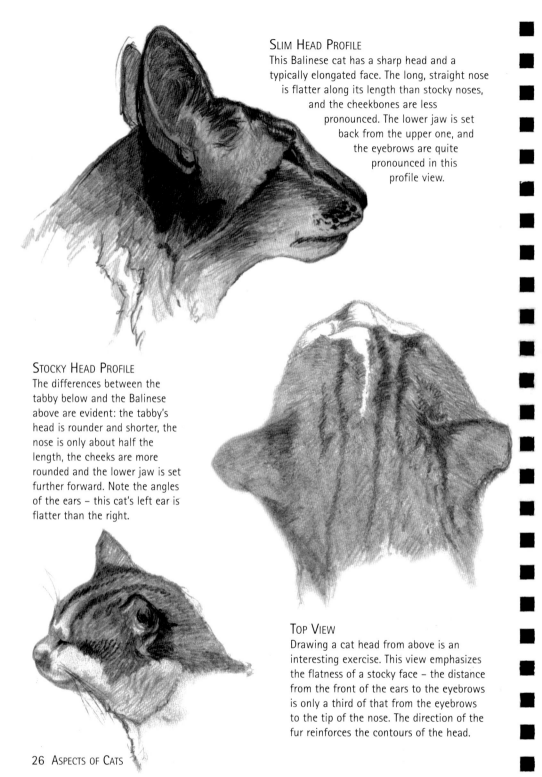

Slim Head Profile

This Balinese cat has a sharp head and a typically elongated face. The long, straight nose is flatter along its length than stocky noses, and the cheekbones are less pronounced. The lower jaw is set back from the upper one, and the eyebrows are quite pronounced in this profile view.

Stocky Head Profile

The differences between the tabby below and the Balinese above are evident: the tabby's head is rounder and shorter, the nose is only about half the length, the cheeks are more rounded and the lower jaw is set further forward. Note the angles of the ears – this cat's left ear is flatter than the right.

Top View

Drawing a cat head from above is an interesting exercise. This view emphasizes the flatness of a stocky face – the distance from the front of the ears to the eyebrows is only a third of that from the eyebrows to the tip of the nose. The direction of the fur reinforces the contours of the head.

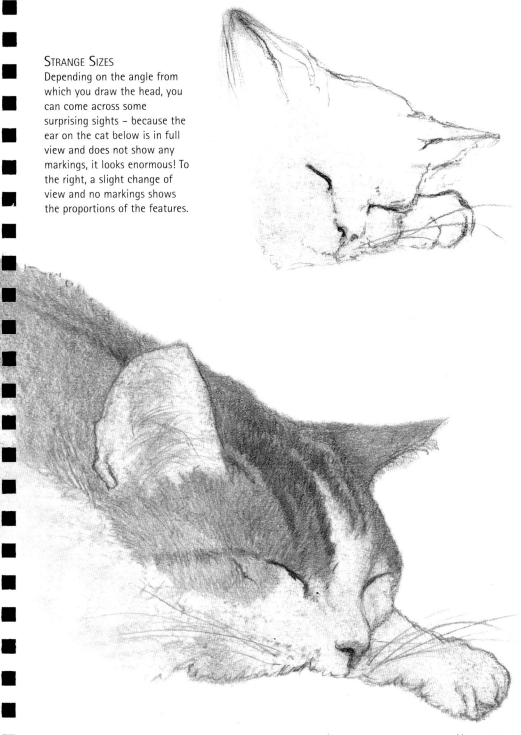

STRANGE SIZES

Depending on the angle from which you draw the head, you can come across some surprising sights – because the ear on the cat below is in full view and does not show any markings, it looks enormous! To the right, a slight change of view and no markings shows the proportions of the features.

Eyes

With their unwavering gaze, cats' eyes have an intensity that forces you to focus on them. Given the variety of eye shapes, sizes, position on the head and pupil size, once you have established the constituent parts of the eye and how to observe and set them down, you can use the eyes as the starting point for portraits. It's worth noting that the space between the eyes is usually about the same as an eyeball – though, of course, this can vary from cat to cat.

This and the following pages employ my method for accurate positioning of the features, by working outwards: when the central elements – eyes, nose and mouth – are in place, you can move confidently out to the ears and top and sides of the head.

Kittens' Eyes

All kittens' eyes are blue once they open after birth, but after a while they take on their final colour. Although they are comparatively large on the head (see page 11), the pupils are even larger when dilated and can take up the whole eyeball area – the 'button eyes' effect.

Pupils and Irises

The features of the head and face also vary between breeds. Judge the position of the eyes, nose and mouth by observing the whole head (see pages 22–27), and consider the length of the neck.

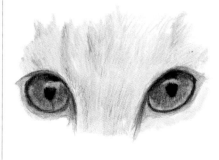

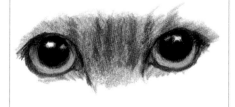

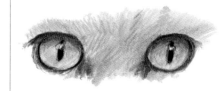

Changing Shapes

From a thin slit in bright light to a circle at night, the pupils take on a multiplicity of shapes and sizes. Note also the shadows at the top, created by the eyelids.

Drawing Eyes

The faint vertical and horizontal positional lines help to find the correct spacing and level for the eyes, and can be erased later. I used graphite and water-soluble coloured pencils.

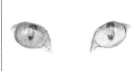

1 *Lightly pencil in the basic shape of the eyes, paying attention to the space between them. Inset: Strengthen the marks before adding the shadows of the eyelids and the pupils – here, the light source stopped the top of the pupils from being an ellipse.*

2 *Use a black water-soluble pencil to block in the pupils, lightly where the light catches the surface, and darker to show the full black. Establish the lightest iris colour tone, leaving the paper white for highlights, and gently blend in the other iris colours on top.*

3 *As you add the iris colours, remember that they may not be exactly the same for both eyes. Apply more black to the outlines and corners; this also helps to check that the colours are accurate. Use a dry pencil for the fur around the eyes, again working outwards from the eyes.*

Closed Eyes

When a cat is asleep, all you can see of its eyes are the corners and what are called the mascara lines around the rims, which show up as a black line. The shadows cast by the eyes are absent, however, leading to a smoother, flatter surface on the face.

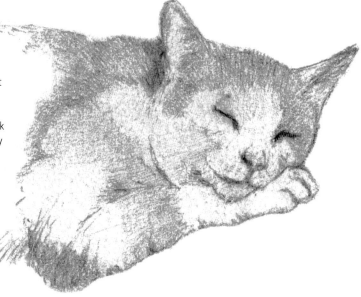

Noses

There is as great a variety of noses among cats as there is of colours and markings – although you wouldn't always know it from cat drawings. If you recognize that the differences are more than just between long and short noses, but take in their height, width and colour and the angle from which you are making a drawing, you are well on the way to portraying them accurately.

When it comes to setting down the delicate details and tone of a particular nose, careful observation is the watchword, as always; but you can find the placing of a nose in relation to the eyes (see right and below) within a triangle. The method shown here is effective for frontal and three-quarter frontal views. You could photocopy pictures of cat heads and see how the triangle works on them.

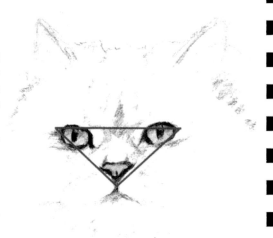

Triangles
The triangle superimposed here contains the nose and eyes. The length of the sides will vary depending on the cat, but using a triangle will help you to establish the basic placings.

Drawing Noses
This front view uses the triangle from the top of the eyes to help place and shape the nose. I used a B graphite pencil and a torchon and eraser to soften the tones.

 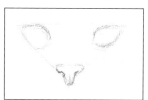 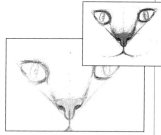

1 *Gently sketch a triangle to take in the eyes and nose, and then create their shapes. Concentrate on getting the placings accurate, and mark the top and middle of the nose. Work very lightly, and make changes as required.*

2 *Start to form the nose, looking to capture its roundness and the delicate curve into the nostrils, which must be in proportion with the length of the nose. Strengthen the shape of the eyes to keep the distances accurate.*

3 *Build up the dark tones on the nose, then indicate the lines to the corners of the eyes and the pupils. Inset: Add the shadows cast by the nose and the inner dark eye lines. The cleft through the nose extends down to the mouth.*

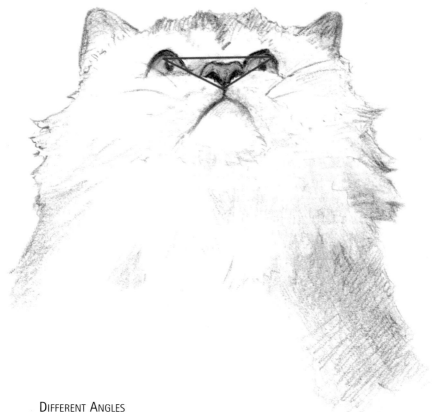

DIFFERENT ANGLES

The triangle that includes the eyes and nose is always there, whatever the angle of the head. A short nose in an upward-tilted head almost flattens the triangle.

NOSE COLOURS

Although it is eye colours that draw the attention, there is a great range of cat nose colours, just a few variations of which are shown below. Changes of temperature affect nose colours, too, with heat darkening pink to red.

DARK BROWN

RED BROWN

OUTLINED PINK-RED

LIGHT PINK

MOUTHS AND WHISKERS

Reduced to the basics, a cat's mouth can be seen as a pair of arcs that include the cheeks, with another, smaller arc below to represent the lower jaw. Within this over-simple definition, however, lies a whole range of shapes, and the angle from which you make a drawing can straighten or intensify the curves to a great degree. Whiskers, too, can be simplified without proper observation – greatly to their detriment – and it's surprising how many people forget to include the eyebrow whiskers.

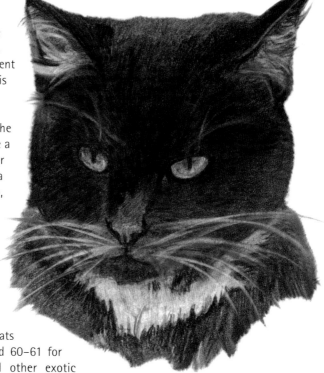

The mouths shown on these pages are of stocky cats – look at pages 12–15 and 60–61 for examples of Siamese and other exotic breeds, whose longer face means that the cheeks are less rounded and meet the nose along more of their length.

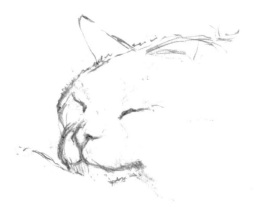

NO TWO THE SAME

White whiskers on a black face show that each whisker has its own droop and fall, and that each grows out of its own separate groove in the cheek. Whiskers are indicators of mood, and you should look to add to the character of your subject by catching their angles correctly.

MOUTH AND CHIN

Depending on the pose, it is very easy to lose the definition of the chin among fur or markings. Views from different positions indicate that the chin can be quite rounded or angular, and small and round or larger and flattish. Make lots of sketches to build up a series of mouths.

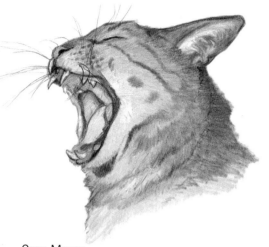

From Below

You are unlikely to be able to draw the underside of a mouth unless the cat is asleep, so seize the chance when it comes. From this angle, the curve of the cheeks and the upward movement of the mouth are lost, replaced by a straightish line. Note the shadow below the upper jaw.

Open Mouth

Unless you are very patient and very lucky, you have to use photographs as reference for yawning or yowling cats. Combine this with accurate observation to find the variations in pink and red tones on the tongue and roof of the mouth, and the length of the teeth.

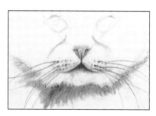

Drawing Mouths

The faint vertical and horizontal positional lines help to find the correct spacing and level for the eyes, and can be erased later. I used graphite and water-soluble coloured pencils.

1 *Gently work down from the nose to establish the cleft of the mouth and shape of the cheeks and lower jaw.* Inset: *Use thin charcoal to show the shadow depth between the jaw and the shape of the chin, then soften the dust with a torchon or paper stump.*

2 *Add a little colour to the cheeks and neck fur while reinforcing the positional lines. Make the first marks to establish the grooves on the cheeks for the whiskers – these are less noticeable on dark- or long-haired cats, but they are always there.*

3 *Lightly sketch in the sides of the face to set a context for the mouth, and indicate the curve of the upper cheeks from below the eyes. Working outwards from the grooves in the cheeks, make bold sweeps for each whisker, concentrating on its individual movement.*

EARS

For the artist, ears are possibly the most challenging detail to set down successfully, because they incorporate so many different textures – the velvety down on the outer surface and the smooth skin on the inside, the elaborate curves and folds and wispy hairs inside, not to mention tufts of hair.

As always, don't assume that all cat ears are the same: apart from the size, shape and setting on the head, look out for individual marks such as the nicked and battle-scarred ears of a tomcat or the strangely folded ears of some breeds.

If you are lucky enough to observe a cat's ears with a strong light source behind them, you can set down the fascinating and intricate pattern of tiny red veins that are otherwise invisible.

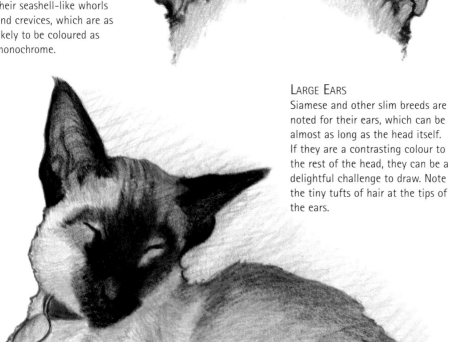

FRONT VIEW
This head-on study of a Devon Rex's ears emphasizes the pinkness of the inner surface and the intricate folds where the ears meet the head – look closely at these, and try to capture their seashell-like whorls and crevices, which are as likely to be coloured as monochrome.

LARGE EARS
Siamese and other slim breeds are noted for their ears, which can be almost as long as the head itself. If they are a contrasting colour to the rest of the head, they can be a delightful challenge to draw. Note the tiny tufts of hair at the tips of the ears.

Top View

Seen from above, the width between the tips of the ears can be surprisingly large, even on a cat with small ears. This view also allows you to catch the contrast between the flat area of one ear and the foreshortened area of the one pointing towards the viewer.

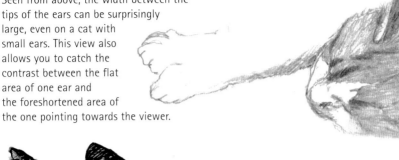

Three-quarter Profile

The bold nature of pen and ink means that you do not have the luxury of tentative marks that can be gone over later. This study focuses on the relationship of the slope of the further ear with the cavity of the inner one; sensitive hairs are suggested by short pen strokes.

Drawing Ears

With the eyes in place, a couple of vertical lines from the pupils helps to set the placing of the ears. I used graphite pencil for this study.

1 Use the vertical and horizontal guide lines to position the inner and outer limits of the ears, then sketch their shape in lightly. Even though not much of the top of the head is visible from this angle, make sure you set its curvature correctly.

2 When you are happy with the proportions and dimensions, strengthen the outlines. Add the pattern that shows the folds on the nearer ear, and make light strokes to suggest the hairs and inner curve, as well as the shading for the back of the head.

3 Darken the whole of the orifice area, looking at how it is lighter away from the hole. Add the darkest shades and lines, bringing out the sharp curves and folds. Use a shard of eraser to wipe away the marks that indicate the lines of pale hairs.

Drawing the Whole Head

The last few pages have looked at the main parts that go to make up a cat's head – the shape, proportions, dimensions and facial features. This exercise pulls all these elements together to produce a head-and-shoulders portrait of a Maine Coon. Apart from being larger overall than most domestic cats, this breed is noted for having a broad nose and large, upright ears.

The starting point is the triangle that can be used to find the relationship between the eyes and nose (see page 30); once you have established that, it is just a matter of careful observation and setting down what you see. This pose illustrates the idea that you can stretch the triangle and still achieve good results – the sides don't have to be regular.

Subtle Distinctions
When the cat's coat is so long and delicate that the colours of the head blend almost imperceptibly into those of the body, take care to get the relationship between the central features and the side of the head absolutely correct.

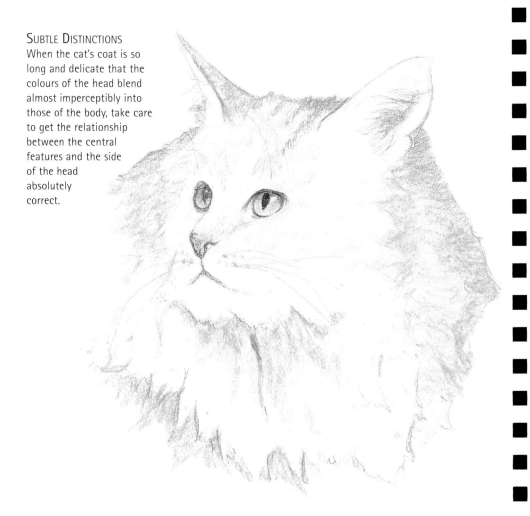

Using Mixed Media

To capture the subtle colours that go to make up this long-haired cat, I used a combination of graphite and water-soluble pencils and pastels on an off-white paper.

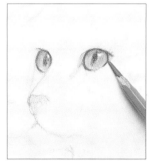

1 Lightly sketch the shape of the eyes in pencil, then use a flattened triangle to find the nose. The width of the nose and the position of the pupils are foreshortened, so get this correct before beginning to round the forms.

2 Working outwards from the triangle, find the position and shape of the ears, using guide lines from the eyes if necessary. Next, begin the curves of the mouth and cheeks, and move outwards again to outline the head.

3 With the facial structure established – step back to check it – strengthen the pupil black and lightly add colour to the irises and the nose. Reinforce the mascara lines and eye corners, then add colour, leaving highlights.

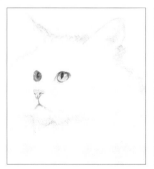

4 After adding a little pink for the mouth, use colours to define the contours of the ears: pink first, then white to soften it and make a base. Using bold colours, start to show the top of the head and under the chin.

5 Free, light strokes create the main areas of colour around the head: use the side of the pencil to shade in the main areas, and the point for the edge of the rough fur around the neck and ruff. Note the single red-brown stroke.

6 Fill in the markings and whisker marks, working lightly at first. Use these colours to strengthen the eyes, nose and mouth. Work round the drawing, emphasizing and softening lines, and add the whiskers and eye hairs.

Feet and Paws

Cats' paws are among the most contradictory features of these contradictory animals: they are soft and extraordinarily sensitive – especially if you try to tickle or stroke them – but at the same time they are tough enough to let the cat run across gravel and stones without apparently flinching. Again, with the claws sheathed they can look harmless, but with the claws extended they show aggression.

When it comes to drawing feet and paws, all too often they are treated like an afterthought and the finished drawing can suffer as a result. Recognize that they are as important as hands and feet in a full-length human portrait, and make an effort to discover the structure beneath the covering, using tone, contour and colour.

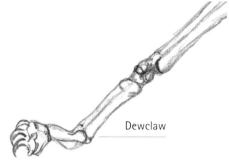

Dewclaw

Front Foot Skeleton
The bones of the toes are controlled by a ligament that runs beneath them. The position here is with the toes and claws retracted – they extend when the ligament is tensed. There is also a fifth toe or thumb, the dewclaw, which is set away from the others.

Claws Extended
Cats' claws are surprisingly small and delicate – though they don't feel like that when they scratch you! They are only fully extended in fright or in a fight, and most often the extent is as shown here. Observe how much of the bone is also extended, and take time to set it down accurately.

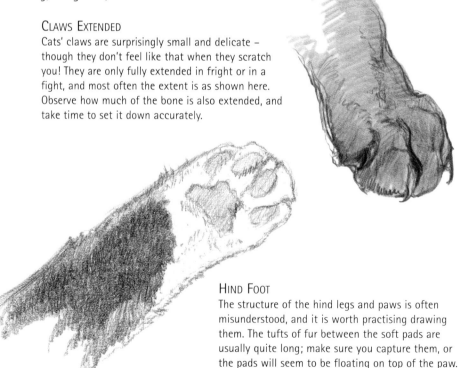

Hind Foot
The structure of the hind legs and paws is often misunderstood, and it is worth practising drawing them. The tufts of fur between the soft pads are usually quite long; make sure you capture them, or the pads will seem to be floating on top of the paw.

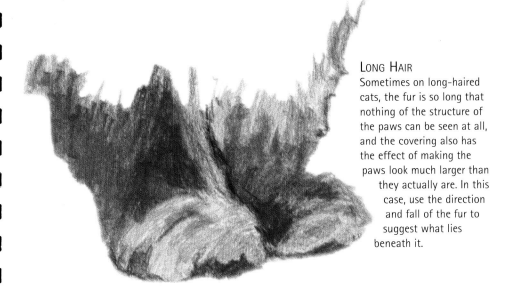

LONG HAIR

Sometimes on long-haired cats, the fur is so long that nothing of the structure of the paws can be seen at all, and the covering also has the effect of making the paws look much larger than they actually are. In this case, use the direction and fall of the fur to suggest what lies beneath it.

CHANGING ANGLES

As with any object, the basic shape of a cat's foot and leg can appear to change with every marginal difference in the angle from which you view it. Even under the same lighting, the colours can change, too.

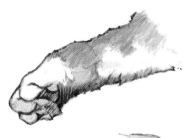

LOOKING FOR LINE

These sketches were made from the same cat; note how smooth the fur is on the hind foot, and how much rougher it is on the front one.

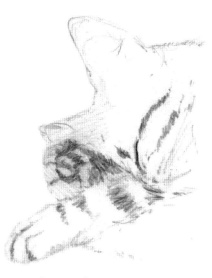

SLEEPING POSITIONS

Much of the attraction of sleeping cats lies in the poses their legs and feet adopt, from front feet curled neatly into the chest to all four limbs stretched out and entangled. This is a typical position, which enables you to study both the top and bottom of the front paws.

TAILS

A cat's tail is an indicator of its feelings – fluffed out in anger, twitching in discontent, upright in pleasure or drooping in illness, it is the cat's main communicator to humans. It is also a fascinating subject in its own right, as no two tails are exactly the same: there are always minute differences in colour, width, length, markings and kinks or curves.

The studies here show tails in isolation and as part of the cat, and this can make or break a drawing – if the tail looks as if it was grafted on, the picture can fail. Look again at the anatomical drawings on pages 8–9, and see how the tail is an extension of the spine, then make your own studies with this knowledge in mind.

SHORT-HAIRED TAIL
A smooth, whip-like tail such as this need not be purely an exercise in line drawing. The ring markings follow the contours around the circumference, and the blending of colours helps to suggest the curves – particularly the blue among the black at the kink in the end.

LONG-HAIRED TAIL
The magnificent bushy fur completely hides the bone, muscle and skin of this tail – but they are there nonetheless, and your drawing must stay true to their possible positions. Using pencil and graphite powder allows you to explore both the line and tone with one medium.

TAIL AS A FOCUS
When faced with a lilac-point Siamese with a dark chocolate tail, especially one that uses its tail so eloquently and as such a contrast, look for a pose that brings the tail into the foreground of the viewer's interest. The face, usually the focal point, becomes almost secondary.

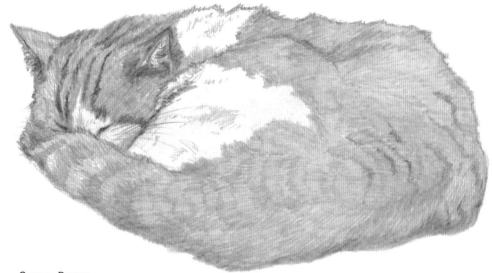

CURLED ROUND
A sleeping or napping cat invariably curls its tail round its feet
and head, and this provides you with a good opportunity to
capture the proportions of the front and rear ends together.
This pencil study also brings out the different intensity of the
tabby markings.

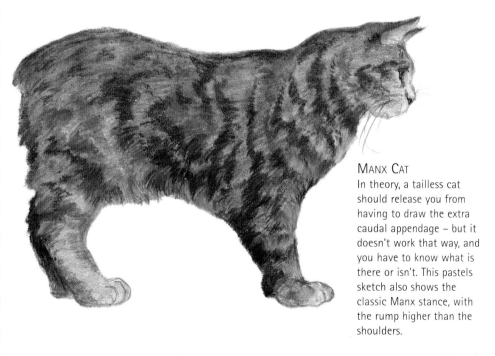

MANX CAT
In theory, a tailless cat
should release you from
having to draw the extra
caudal appendage – but it
doesn't work that way, and
you have to know what is
there or isn't. This pastels
sketch also shows the
classic Manx stance, with
the rump higher than the
shoulders.

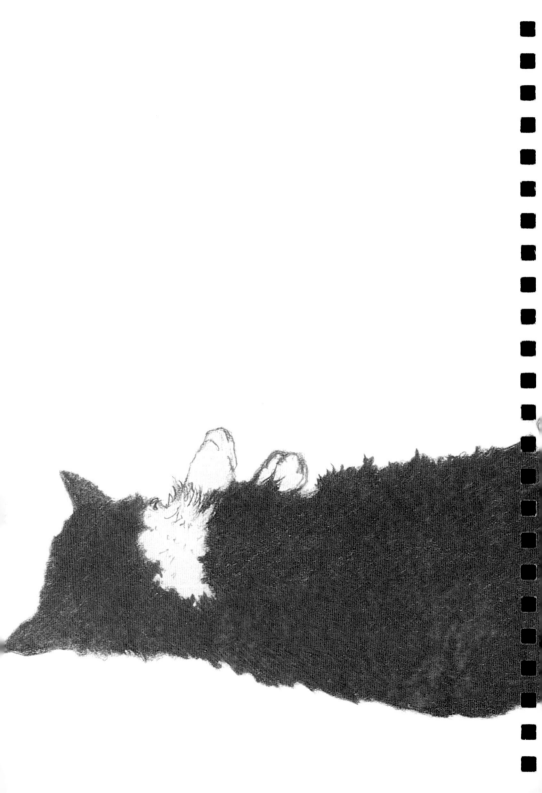

FUR AND MARKINGS

All cats may appear to be grey when
stalking around in the dark, but in
the light their markings and fur
texture are their most instantly
recognizable and distinctive features.
In this chapter, learn how to capture
the wide variety of feline markings
and colours, and to sketch semi-
abstract close-ups of hair and fur.

Markings

All cats have fur markings of one sort or another. The coats of even completely white or black cats produce patterns through shaded or shadowed areas of fur; if they are long-haired, the fall of the fur creates creases and hollows; and short-haired cats' muscles and bone structure are prominent in different poses.

The most immediate challenge for the artist, however, is how to capture the sheer range of markings on offer: solid or barely distinguishable tabby stripes, subtle Siamese gradations of white, chocolate and lilac, blocks of tortoiseshell colouring, and many more.

One of the best exercises is to experiment with as many different media as you can, to draw the same cat: basic pencil, pen and ink and pastels all produce effective results, even before moving on to other tools.

Tortoiseshell and White

Although this typical marking pattern can go unobserved simply because it is so often seen, it provides a wonderful opportunity for drawing bold colours and black, and semi-tabby markings and pure white – all in one cat. Conté pencils help you capture the fur texture as well.

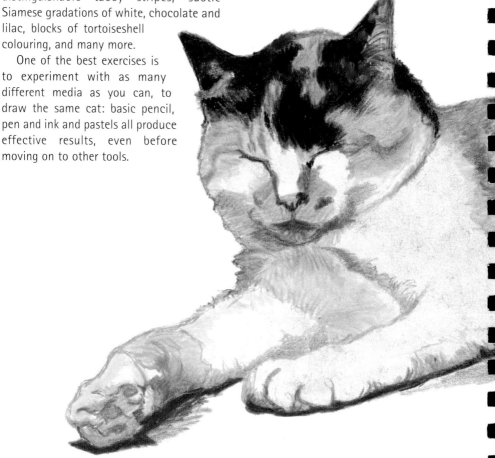

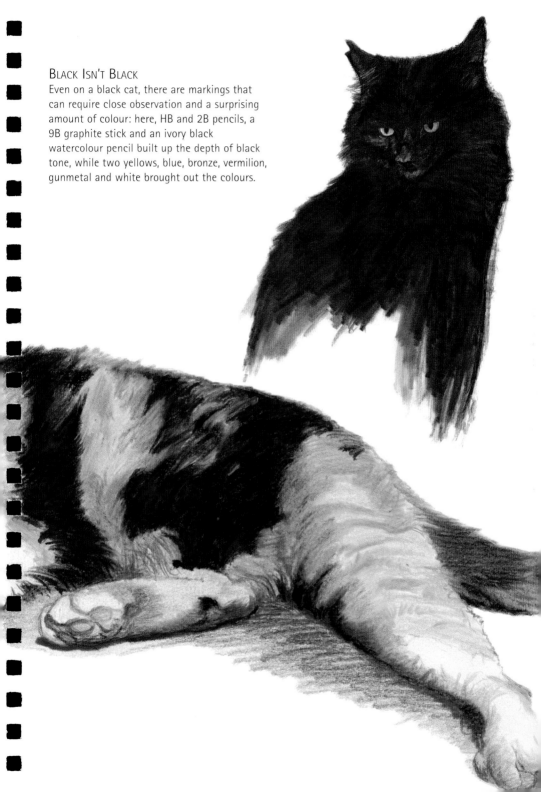

BLACK ISN'T BLACK

Even on a black cat, there are markings that can require close observation and a surprising amount of colour: here, HB and 2B pencils, a 9B graphite stick and an ivory black watercolour pencil built up the depth of black tone, while two yellows, blue, bronze, vermilion, gunmetal and white brought out the colours.

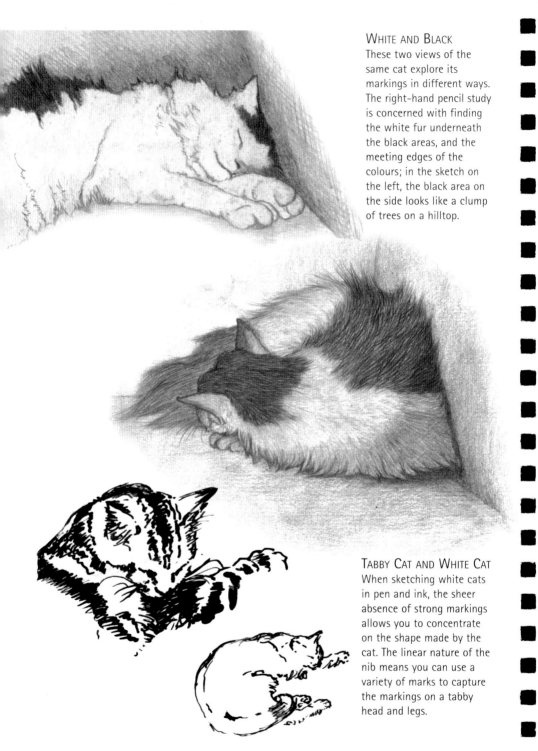

WHITE AND BLACK
These two views of the same cat explore its markings in different ways. The right-hand pencil study is concerned with finding the white fur underneath the black areas, and the meeting edges of the colours; in the sketch on the left, the black area on the side looks like a clump of trees on a hilltop.

TABBY CAT AND WHITE CAT
When sketching white cats in pen and ink, the sheer absence of strong markings allows you to concentrate on the shape made by the cat. The linear nature of the nib means you can use a variety of marks to capture the markings on a tabby head and legs.

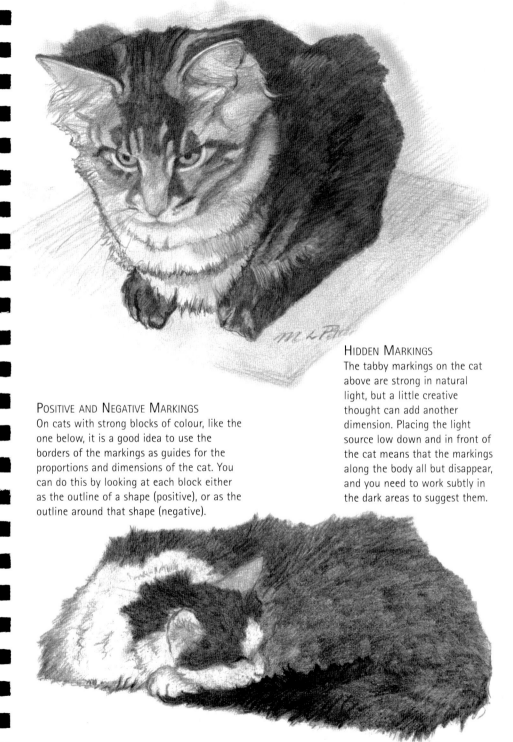

HIDDEN MARKINGS
The tabby markings on the cat above are strong in natural light, but a little creative thought can add another dimension. Placing the light source low down and in front of the cat means that the markings along the body all but disappear, and you need to work subtly in the dark areas to suggest them.

POSITIVE AND NEGATIVE MARKINGS
On cats with strong blocks of colour, like the one below, it is a good idea to use the borders of the markings as guides for the proportions and dimensions of the cat. You can do this by looking at each block either as the outline of a shape (positive), or as the outline around that shape (negative).

Short Hair

The first thing to note here is that the page heading is a description of any cat, slim or stocky, whose hair grows close to its body, not 'Shorthair', which is the name for 15 or so pedigree breeds.

By taking a not particularly observant or close glance, it is possible to see the markings on short-haired cats solely as solid blocks of different colours. You can get some interesting results by drawing in this way, but you are likely to miss out on a great deal that can add subtlety and realism to your artworks. The close covering of fur allows you to see the masses of muscles under the skin – and with some slim cats, you can observe the bones of the shoulders and tail as well.

Working in one colour – monochrome – enables you to concentrate on the direction in which the hair lies and the shadows that are created as the skin beneath folds and is stretched in different poses, as well as developing line and tone. Moving into more than one colour provides an opportunity to work on gradations and even to exaggerate any apparent smoothness of texture.

Drawing the Shadows

I used a pen and various dilutions of ink for this close-up study of the meeting point of a front leg and chest. The shadows between the hairs have an abstract feel.

1 *Dip a finger, or brush or sponge, into a weak dilution of ink and draw the base wash, following the contours of the leg and chest. To darken the area behind the leg on the left, use full-strength ink. Define the meeting edge with a pen.*

2 *Use the weakest ink dilution to start drawing the texture of the short fur along the skin: ticks and flecks appear as you make small directional marks. Repeat over the darker wash, using the full-strength ink and following the fur direction.*

3 *Use a medium dilution to draw the lines that connect the lightest flecks with where the hair stands away from the skin – the negative, shadowed areas. Inset: Emphasize the right-hand edge of the leg, and darken the left-hand shaded areas.*

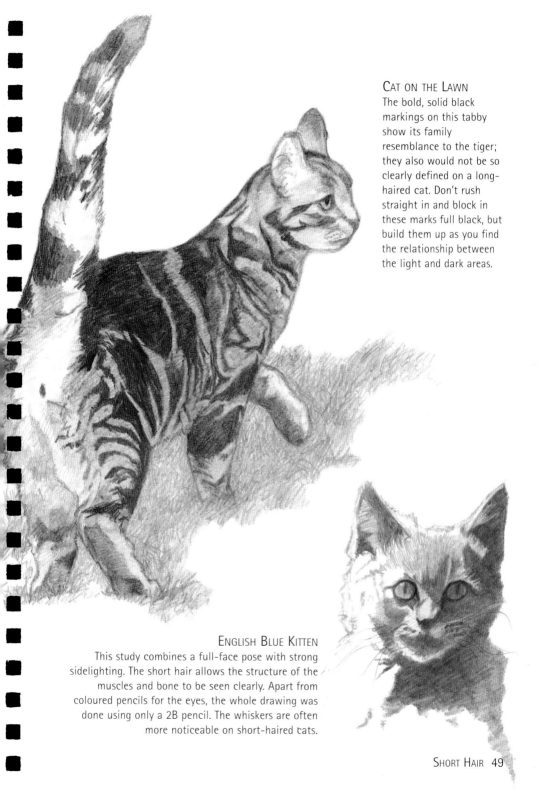

CAT ON THE LAWN

The bold, solid black markings on this tabby show its family resemblance to the tiger; they also would not be so clearly defined on a long-haired cat. Don't rush straight in and block in these marks full black, but build them up as you find the relationship between the light and dark areas.

ENGLISH BLUE KITTEN

This study combines a full-face pose with strong sidelighting. The short hair allows the structure of the muscles and bone to be seen clearly. Apart from coloured pencils for the eyes, the whole drawing was done using only a 2B pencil. The whiskers are often more noticeable on short-haired cats.

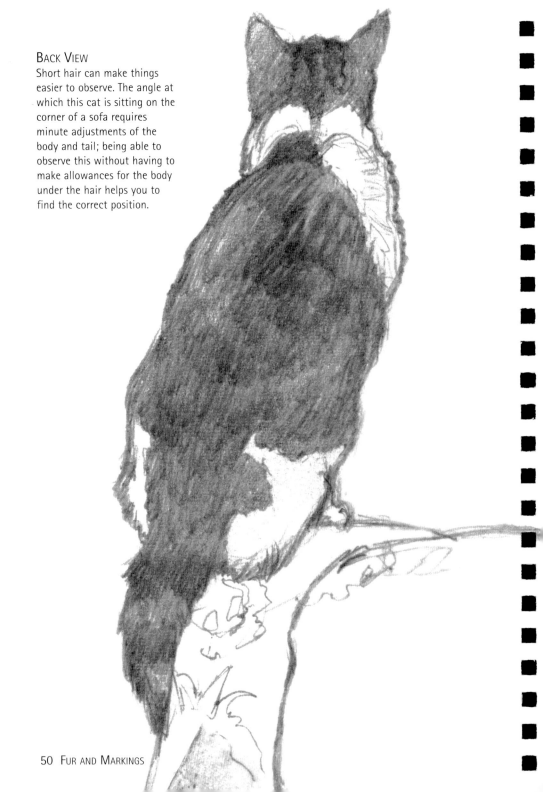

BACK VIEW

Short hair can make things easier to observe. The angle at which this cat is sitting on the corner of a sofa requires minute adjustments of the body and tail; being able to observe this without having to make allowances for the body under the hair helps you to find the correct position.

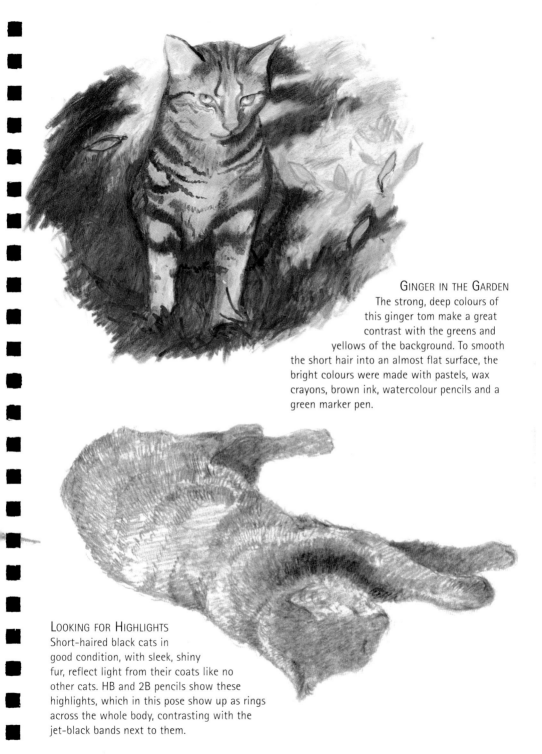

GINGER IN THE GARDEN

The strong, deep colours of this ginger tom make a great contrast with the greens and yellows of the background. To smooth the short hair into an almost flat surface, the bright colours were made with pastels, wax crayons, brown ink, watercolour pencils and a green marker pen.

LOOKING FOR HIGHLIGHTS

Short-haired black cats in good condition, with sleek, shiny fur, reflect light from their coats like no other cats. HB and 2B pencils show these highlights, which in this pose show up as rings across the whole body, contrasting with the jet-black bands next to them.

LONG HAIR

For the artist, the differences between short-haired and long-haired cats are far more wide-ranging than there being a more fluffy surface to stroke. (Again, note that there are over 40 recognized varieties of pedigree 'Longhair' cats, but the net has been cast much wider here.)

Long hair tends to disguise the shape underneath, so your powers of observation are crucial. The roundness of a skull and the length of a neck may be invisible, and the entire body may disappear when the cat sits down – let alone other impossible angles and shapes being created with even a small shift of viewpoint – but on the credit side, you may have the opportunity to use broader, more sweeping strokes to delineate hair direction than are possible with short-haired cats.

LONG-HAIRED HEAD
Combine long head hair that falls into a pyramid shape with the retroussé nose and wide-set eyes of a long-haired Russian blue, and you have to work hard to avoid making assumptions. The triangle method of setting the features still applies (see page 30).

FIND THE BODY
On a pedigree Longhair with a large ruff and body fur, and a sprawling, curled-over tail, the outline is very different from the skin, muscles and bone beneath – but don't ignore the basic anatomy, otherwise your drawing will lack conviction. Black crayon is great for following the flow of the hair.

Capturing Layers of Hair

To capture the subtle colours that go to make up a patch of long hair, I used a combination of graphite and water-soluble pencils and pastels on off-white paper.

1 Use the lightest base colour – here, yellow – to lay a base for the study, then work from this to the darkest tones, following the general direction of the hair. The yellow may not show up much in the end, but is necessary nonetheless.

2 Continue to lay on the yellow, orange and brown, all the time aiming to catch the fall of the main strands and the most prominent hair. Apply a light grey to suggest the darkest tones, but not so that it obscures the layers beneath it.

3 Use a dark brown pastel to add the darkest hair at the bottom, still working lightly and freely with the side of the pencil. It may all appear a bit messy now, but if you are drawing what you see, the next stages will pull everything together.

4 Strengthen and deepen the chocolate-brown strands, moving the pastel dust with a torchon or paper stump. Inset: Use upward strokes to drag the dark strands into the lighter ones, and blend in white to emphasize light colours.

5 Use a dark umber to create a depth in the darkest tones that matches the richness of the top hair, going over the white if necessary. Apply dark blue with the side of the pencil to suggest the highlights that sit on the darkest colours.

6 For the final stages, switch to using the points of the appropriate colours, and use these to sharpen the outlines and enhance the definition between the layers – a warm ochre avoids too much of a contrast. Stop before you overwork the study.

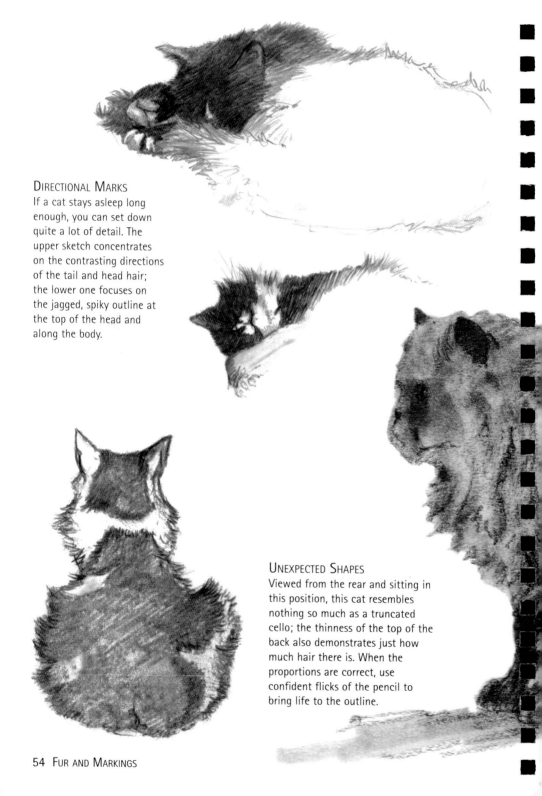

DIRECTIONAL MARKS

If a cat stays asleep long enough, you can set down quite a lot of detail. The upper sketch concentrates on the contrasting directions of the tail and head hair; the lower one focuses on the jagged, spiky outline at the top of the head and along the body.

UNEXPECTED SHAPES

Viewed from the rear and sitting in this position, this cat resembles nothing so much as a truncated cello; the thinness of the top of the back also demonstrates just how much hair there is. When the proportions are correct, use confident flicks of the pencil to bring life to the outline.

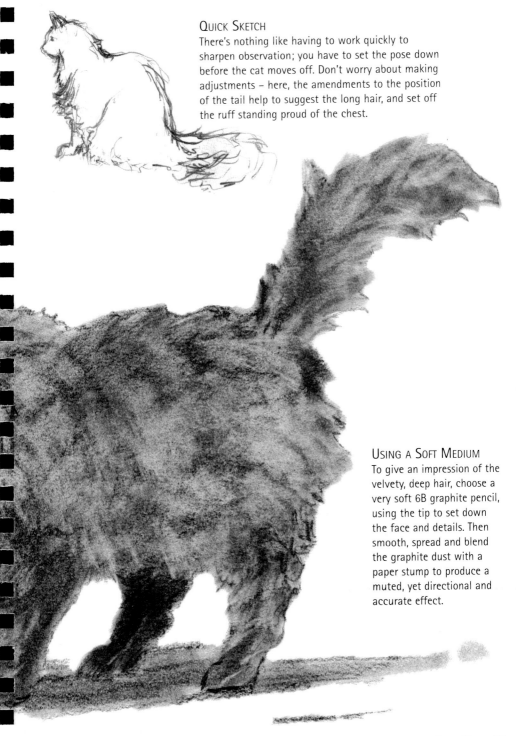

QUICK SKETCH
There's nothing like having to work quickly to sharpen observation; you have to set the pose down before the cat moves off. Don't worry about making adjustments – here, the amendments to the position of the tail help to suggest the long hair, and set off the ruff standing proud of the chest.

USING A SOFT MEDIUM
To give an impression of the velvety, deep hair, choose a very soft 6B graphite pencil, using the tip to set down the face and details. Then smooth, spread and blend the graphite dust with a paper stump to produce a muted, yet directional and accurate effect.

DRAWING HAIR AND MARKINGS

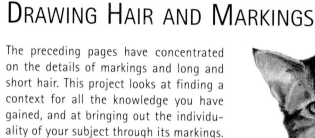

The preceding pages have concentrated on the details of markings and long and short hair. This project looks at finding a context for all the knowledge you have gained, and at bringing out the individuality of your subject through its markings.

To do this effectively involves spending time just looking at the cat – hopefully, a pleasure rather than a chore – and observing how its markings and colours run across or along the contours of the body. Then you have to decide which angle is best for your purposes; as the drawings in this section show, a front view may not always be the most telling one, but it does allow you to use the triangle method to set the dimensions and proportions for working outwards (see page 30).

MAINE COON KITTEN
One of the most crucial points to look out for is capturing the effect of colourful markings meeting an expanse of white fur. You need to concentrate on both the smooth texture and the ragged edges of the markings themselves.

STRONG MARKINGS
Sometimes it seems that a cat arranges itself into a pose specifically to be drawn – the outstretched leg here is mirrored by the angle of the tail, and the magnificent markings range from thin, subtle stripes on the head to the blocks of black on the back.

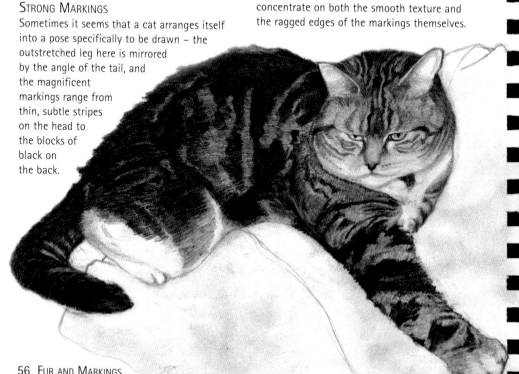

DRAWING SPIKY EDGES

To capture the effect of the spiky fur at the edges of the body, I used watercolour pencils, wet and dry, after establishing the groundwork with a 2B pencil.

1 *Lightly pencil in the position of the eyes and the nose, using the triangle method on page 30; kittens' facial proportions are different to those of adult cats. Use horizontal and vertical guide lines to help you place the features and top of the head.*

2 *Map out the ears and side of the head, then add the base colour, emphasize the eye areas and apply light layers for the semi-translucent ears.* Inset: *Add the iris colours and place more head markings before defining the chin with white and purple.*

3 *Work down to find the neck and ruff, using directional strokes; gunmetal and green are good for the sheen of the fur. Reinforce the markings and chin further, and build up the multicoloured chest hair in layers, checking constantly for accuracy.*

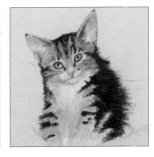

4 *When you are satisfied that the markings are correct, start to blend the colours around the ears, eyes and mouth. Wet the tip of a torchon or paper stump, and lightly touch the colours across – practise on scrap paper first.*

5 *Use scribbled marks to add the spiky fur of the body and legs. On a white base, use dry and wet watercolour pencil to blend in the layers on the chest. Keep looking at the whole drawing and adjust colours as required, for instance in the ears.*

6 *Continue to work over the whole drawing, blending with a torchon and strengthening the colours – but beware of overworking the picture and losing its freshness. You can suggest how the stripes describe the contours and form on the legs.*

Black Cats and White Cats

For the artist, there are no such things as completely black or white cats. Elegant pedigree Foreign Whites have the 'whitest' fur, making them look like alabaster, but even they can be seen as a riot of colours and gradations – reflected light from the ground, highlights, under-fur, winter coats, and shadows as the fur grows in different directions. In addition, there are many white cats that have a fair amount of colour in them as a matter of course.

The sheen and highlights on a short-haired black cat immediately introduce colours, and the winter coat on a black cat is more than likely to be brown or chocolate and grey-white (you notice this most when the cat moults in spring).

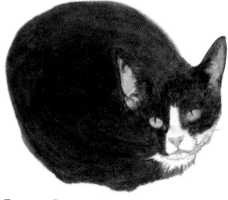

Textured Black
You can draw a black cat as a solid mass, for instance with a brush and ink or marker pen; or use a more linear technique, such as pencil, to bring out the texture and direction of the fur.

Drawing Black Fur
I used tinted paper for this area of black fur, and concentrated on capturing long strands of hair with pastels and charcoal.

1 To suggest the lightest undercoat colours, apply burnt carmine and then burnt umber, following the direction of the fur and creating contour lines and sweeps of long hair. Add some indigo and blend the colours with a torchon, again following the fur direction.

2 Use the side of a soft charcoal stick to cover the undercoat, working lightly at the paler top and more firmly on the darker areas below. Blend these layers with a torchon or paper stump, and add more charcoal if you want to create a denser surface.

3 Cut a small wedge-shaped piece from an eraser, and use this to draw into the paler areas sgraffito-style. Flick the eraser to suggest hair ends. Hold a sharpened black pastel pencil away from the tip, and draw long strokes across the erased areas.

NEGATIVE WHITES

Unless you draw a pure white cat on a deep-pile white rug – a challenge in itself – you should be able to use the surface on which it is to practise negative drawing. This means treating the cat as the blank space in the picture, and starting by working on the background.

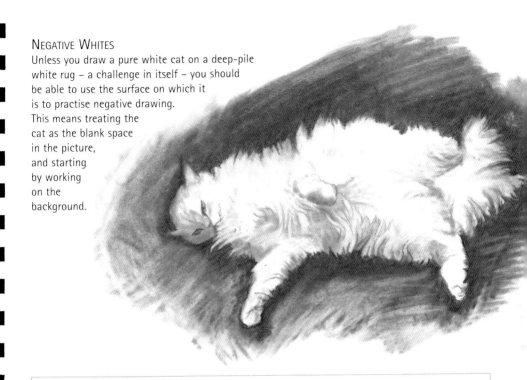

DRAWING WHITE FUR

An area of short hair works best to illustrate the colours that can be present in white fur. I used pastels on light-grey tinted pastel paper, which emphasizes the bright colours.

1 *Use the side of a white pastel to establish the base, then apply lilac quite firmly to suggest the skin and muscle contours. Add a little sky blue to widen the tonal range, and draw single strokes of white into the colours for the overlaps of hair.*

2 *Apply lemon yellow, followed by light strokes of orange earth, to bring out the warmth of the lightest tones – don't worry about slightly exaggerating the colours at this stage, as you can knock them back with more white. Follow the form with the lilac.*

3 *Use the point of a sharp light-grey pastel pencil to pick out the lines of the hair and establish the subtle shadows; work over all the colours as required, and press lightly until you have caught the movement, then reinforce them gradually.*

SIAMESE CATS

Popular among owners for many years, Siamese cats are regarded as a typical exotic breed, with attenuated bodies and long legs and tails, extended muzzles, almond eyes and large ears. And because of these differences to the stockier cats that most of us see as the norm, drawing Siamese cats demands accurate observation and the jettisoning of assumptions about proportions, dimensions – and particularly colour.

The various types of Siamese colouring and markings – seal-point, lilac-point, chocolate-point, and the 'tabby' variants of these – are of more importance to the breeder and show judge than to the artist, but they way in which they blend and merge into the light base colour makes drawing these cats a fascinating challenge. Unless you make monochrome studies, softer media, such as pastels and water-colour pencils, are your best tools.

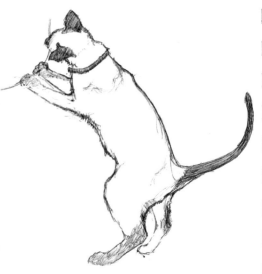

PLAYFUL POSE
The length of Siamese bodies and legs can be best seen when they have to stretch. This cat was playing with a piece of string when this sketch was made using ballpoint pen, and the pose demonstrates the superb sense of balance, with the long tail as a counter to the body.

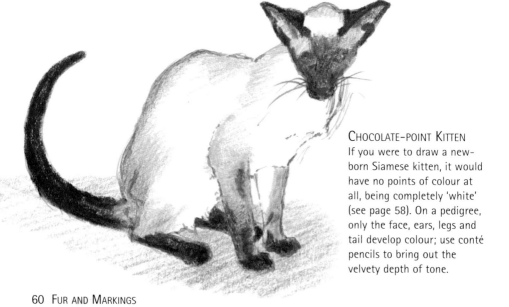

CHOCOLATE-POINT KITTEN
If you were to draw a new-born Siamese kitten, it would have no points of colour at all, being completely 'white' (see page 58). On a pedigree, only the face, ears, legs and tail develop colour; use conté pencils to bring out the velvety depth of tone.

LOOKING SIDEWAYS

The classic seal-point markings offer the opportunity for working from very light tones to very dark ones. I used watercolour pencils to shade in an HB pencil base.

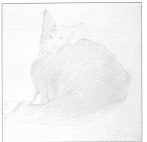

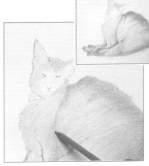

1 *Working outwards from the eyes and nose (see page 28), sketch the head and then move on to the body; the foreshortened angle needs care for accuracy. Find the relationships of the legs, feet and tail and draw them, then add the curves of the hind leg.*

2 *Establish the base colour over the lighter areas across the cat, using between the tip and the side of a flesh pink watercolour pencil. Follow the direction of the fur with a light yellow layer. When brown is applied, these undercolours soften and blend it.*

3 *Use sienna or ochre water-colour pencils to build up the contour lines and direction of fur along the body and back. Inset: Reinforce these areas with umber, and add the shadow areas and folds, then lay in the darker parts of the legs and paws.*

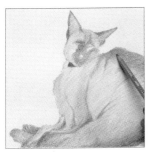

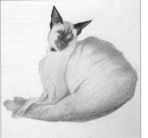

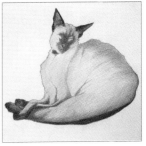

4 *Move onto the face with the umber, moulding the ears and mask; the colour obscures the details of the face and defines the cheek shape on the left. Add lilac gently across the body, then blue for the collar, which is mirrored in the lilac.*

5 *Reinforce the darkest browns, then sculpt the nose and mouth with the HB pencil. With all the parts in place, you can now go over them with the browns and blues in layers – work patiently, as the 'solid' areas are anything but solid.*

6 *The bottom of the back and tail is the largest dark area – don't use black, but continue building up tones with browns and blues. Work carefully to get the legs and feet right, using pencil outline for definition where necessary, and add light red for the pads.*

Tortoiseshell Cats

The term 'tortoiseshell' covers a great range of colours and combinations: the classic orange and black, and orange, black and white tortoiseshells are joined by cats where the orange is almost yellow, and ones with more flecking than solid blocks of colour, not to mention where a mostly white cat has a little tortoiseshell colouring. Whatever the colours, the chances are that any tortoiseshell cat you draw will be a female; very few are males, and those that there are tend to be sterile.

Although you can use monochrome media successfully to draw tortoiseshell cats, the opportunities the markings offer for practising contrast and blending are almost unrivalled. Like snowflakes, no two tortoiseshells are exactly alike, so look to bring out the individuality in the markings and colours.

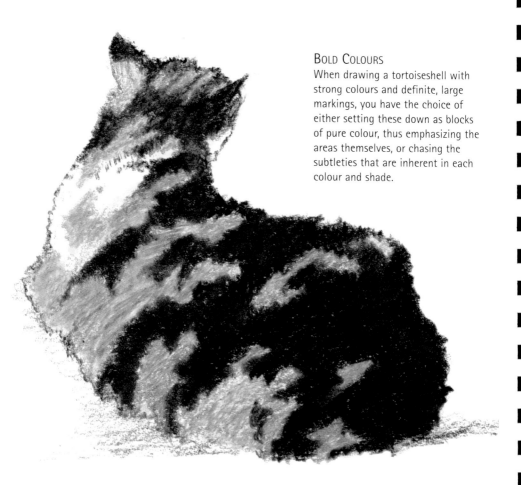

Bold Colours
When drawing a tortoiseshell with strong colours and definite, large markings, you have the choice of either setting these down as blocks of pure colour, thus emphasizing the areas themselves, or chasing the subtleties that are inherent in each colour and shade.

DRAWING TORTOISESHELL FUR

Water-soluble coloured pencils are excellent for setting down tortoiseshell colours. I drew on warm-toned paper to enhance the orange; white paper would enhance white.

1 *Start by laying down an even layer of the lightest colour as a base, using the side of the pencil. This base should cover the whole coloured area, as even the lightest colour fur is going to be a blend of two or more shades.*

2 *Use a golden brown to build up the borders of the darker colour; this allows you to change the shape of the patterning, where black wouldn't. Make light strokes in the direction of the fur with the tip of the pencil.*

3 *Work some more orange into the lighter colours. Keep observing the fur and adjusting the strength of stroke: there will be lighter and darker areas within each 'block' of colour, and this helps to pick them out.*

4 *By adding darker tones to the darker areas, you are making a greater differentiation between the two areas. When adding black, keep the stroke direction the same as the orange, and avoid drawing a solid mass.*

5 *Suggest individual black hairs with short strokes at the edge and more definite hatching in the centre. Apply a third layer of black by dipping the pencil in clean water and making short strokes in the direction of the fur.*

6 *Add more colours to the orange, wetting the pencil tip as required. You can go over the black, so long as the direction is consistent. Add blue highlights to the black, and keep making colour adjustments as required.*

TABBY CATS

The word 'tabby' comes from the Turkish 'tabi', which describes a woven cloth with distinctive striped markings. Capturing the markings on tabby cats is an exploration in any medium: short, zigzag marks with pen and ink; bold, flowing strokes with a charcoal stick; painstaking, hair-by-hair directional lines with a pencil; or scribbles from chalk, pastel or watercolour pencil, the latter blended with a paper stump.

All the advice in this chapter so far is appropriate for tabbies – black and white are rarely solid blocks so you need to practise blending shades; and you get short- and long-haired versions, which make differing demands on your skills. That said, it is just as rewarding to ignore colour and produce monochrome studies, as these help find form and simplicity.

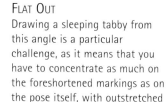

FLAT OUT
Drawing a sleeping tabby from this angle is a particular challenge, as it means that you have to concentrate as much on the foreshortened markings as on the pose itself, with outstretched legs. However, if you take the time to get it right, the result can be an arresting image.

TABBY HEAD
This pencil study of a long-haired tabby Maine Coon uses the mono-chrome nature of the medium to show how you can build up the darkest areas using hatching that follows the direction of the fur. Note the tufts of hair on the tips of the ears, and the curve of each whisker.

AMERICAN SHORTHAIR TABBY

To suggest the bold markings on this cat's back, I used a combination of soft media – 2B graphite stick, charcoal and pastel pencils – and cleaned up the resultant dusty mess afterwards.

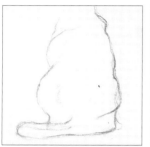

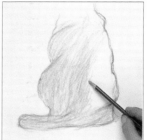

1 Use a graphite stick to lightly establish the outline; in this position, there are taut and loose areas of skin and muscles, and your marks must correspond to these contours. Add the creases of the shoulders and legs, redrawing until satisfied.

2 Switching to a grey pastel pencil, use the side to gently lay a base colour over the whole cat. Make sure you follow the curves of the back, tail and legs, as this stage acts as the basis for all subsequent markings, and you therefore need to be accurate.

3 Block in the main areas of black with a stick of soft, rich charcoal, using the dusty texture to suggest the outlines and stray flecks of black fur. Use both the point and the side to find the outline, and then apply pressure to achieve a deep black.

4 Where the markings meet the outline, use the charcoal tip to follow your original lines. Shape the contours with dark and light strokes – the markings are unlikely to go completely against them, but they are also unlikely to be symmetrical.

5 With a torchon or paper stump, pull the charcoal dust from the dark markings into the grey areas between them, looking for highlights and dark and light patches. This loses the hard edge of the black and stops it from 'floating' on the grey.

6 Use a soft eraser to remove some of the blended areas and to reaffirm the grey while suggesting the lightest strands. Rework the black as you go. Cut small wedges of eraser, and reinforce the texture. Inset: Follow the direction of the fur.

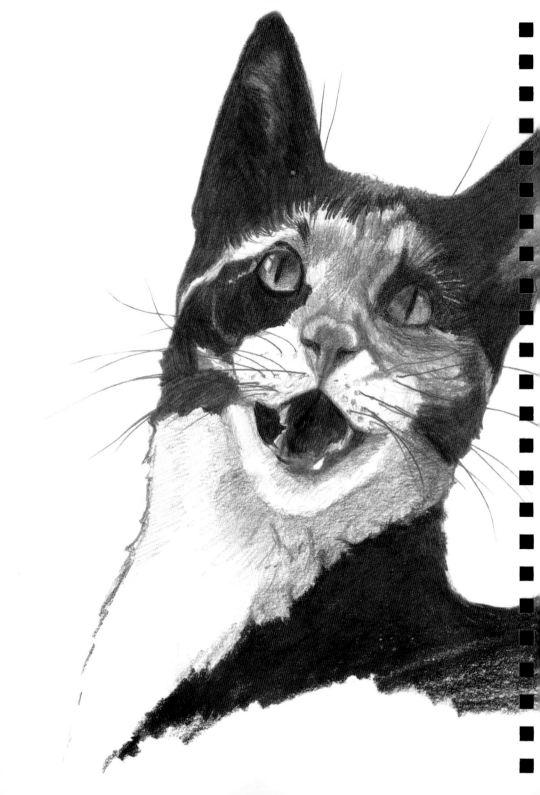

CAT POSES

Whether they are in repose or full of
activity, cats are always wonderfully
rewarding to draw in context. This
chapter brings together all the skills
you have developed so far, and looks
at how you can set down what you
see, both by direct observation and
by using reference materials as aids.

Quick Sketches and References

However quick an artist you are, and however compliant your subject is, there is no way you are going to be able to catch the speedy and dynamic actions of a cat without recourse to reference materials – or, put simply, photographs. Despite the horror with which using photographs is regarded in some circles, they are an invaluable aid to the artist, so long as they are used with forethought and care.

The best photos are those that you have taken yourself, because they are allied to your visual memory of the actual cat. Keep in mind that the shadows in photos have little subtlety, and that working from two dimensions into two dimensions is only a substitute for reality; then combine photos with making and studying quick sketches, and you can use your judgement to produce accurate drawings.

Quick Studies

The more sketches you make, the better you become and the bigger a reference library you build up. Change the angle and viewpoint, add or ignore detail as you prefer, and be prepared to abandon one sketch to start on another that may add to your repertoire.

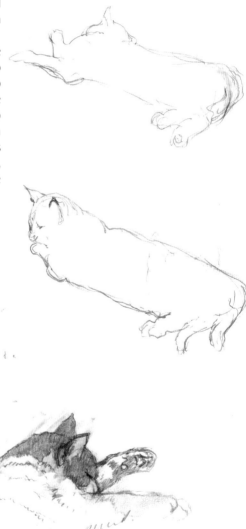

LOOKING FOR THE LINE

Ballpoint is a good medium for making studies in a very short space of time before your subjects move – yet the effect of using many lines to define shape and form gives them a freshness and vitality. Don't be tempted to 'finish' them further and risk overworking them.

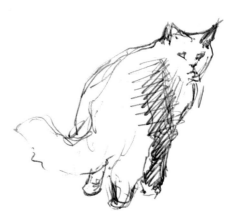

GRIDDING UP

A traditional method of making copies, this involves drawing a grid onto an artwork or photograph – or a thin sheet of clear plastic or paper if you want to keep the original unmarked – making another grid on paper, and carefully drawing square by square onto this new grid.

You can also enlarge and shrink originals this way; make sure that the proportions of the grids are the same.

Start making marks lightly, square by square, until you are happy with the outline and major details, and only then work on the textures and subtleties. Pay special attention to the places where the outline meets the grid lines, and use these spots to move on to the next squares.

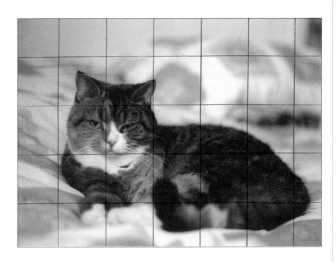

MAKING ALLOWANCES

The pose and lighting in this photo are attractive, but they throw up problems in the difference between the hard shadows on film and soft ones in the actual cat. A ballpoint study is a way of resolving how to make the leap between the two, based on what you observe from life.

UNUSUAL MEDIA

The speed with which you may have to sketch a cat can be great for freeing ideas and trying out experiments. The thickness of a marker pen nib means you have to work boldly for the most part and simplify the contour markings as much as possible.

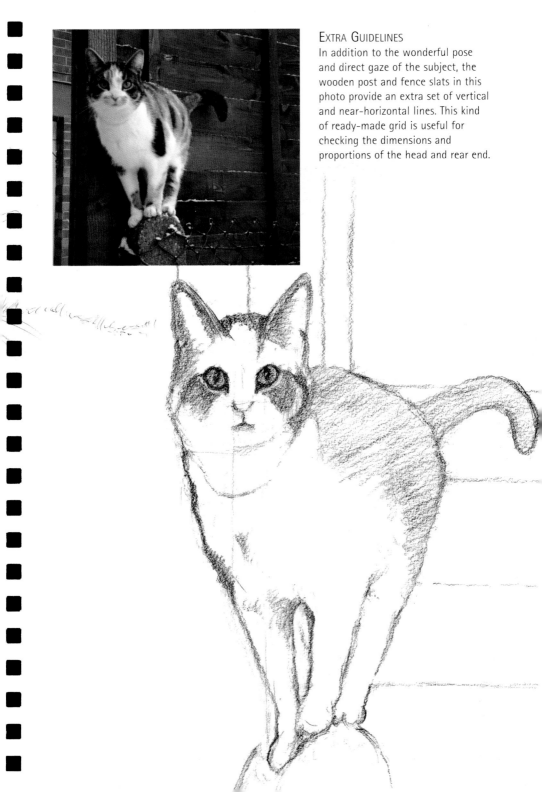

Extra Guidelines

In addition to the wonderful pose and direct gaze of the subject, the wooden post and fence slats in this photo provide an extra set of vertical and near-horizontal lines. This kind of ready-made grid is useful for checking the dimensions and proportions of the head and rear end.

SLEEPING

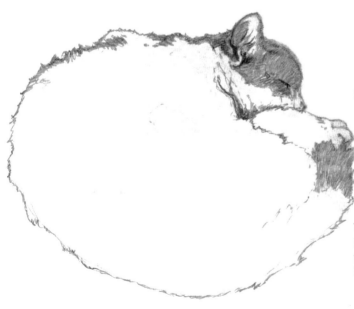

As the Californian poet Rosalie Moore put it, 'Cats sleep fat and walk thin', and a sleeping cat provides you with the opportunity to study and draw some very unusual and un-catlike shapes – not to mention having a still, motionless subject for a change!

Before starting, if possible spend a little time deciding on the angle from which you want to work, as this can transform a pose from good into fascinating. In the same way, think about what appeals to you most about the pose: the whole cat, or maybe one detail or part. Don't forget to include the setting where appropriate – the pose on the opposite page would look very strange if some of the sofa had not been added.

You may be lucky enough to finish your drawing before the cat wakes and moves – if not, just add the incomplete sketch to your collection and watch the cat in order to catch the pose some other time.

Here, the markings, angle and shape of the 'front end' of the cat catch the attention.

Cat in the Round

With just one ear and a paw breaking out of a circle, this kind of pose is too good to miss. Enough detail is added to show the head, tail and leg, but the other areas are left untouched. This has produced a stark, illustrative effect that uses the colour of the paper to its full extent.

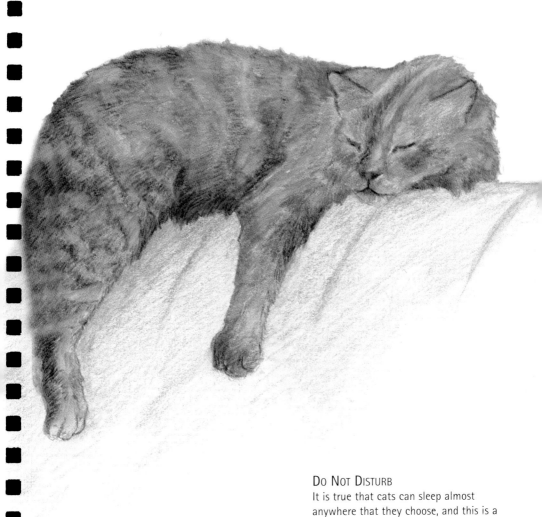

Do Not Disturb

It is true that cats can sleep almost anywhere that they choose, and this is a boon to the alert artist. This cat's habit of sleeping along a sofa back, with legs down both sides, made it an ideal subject for an unusual pose.

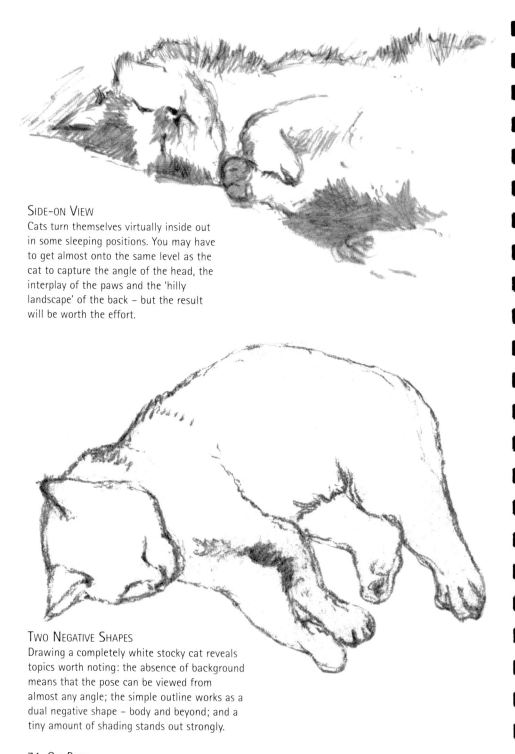

SIDE-ON VIEW

Cats turn themselves virtually inside out
in some sleeping positions. You may have
to get almost onto the same level as the
cat to capture the angle of the head, the
interplay of the paws and the 'hilly
landscape' of the back – but the result
will be worth the effort.

TWO NEGATIVE SHAPES

Drawing a completely white stocky cat reveals
topics worth noting: the absence of background
means that the pose can be viewed from
almost any angle; the simple outline works as a
dual negative shape – body and beyond; and a
tiny amount of shading stands out strongly.

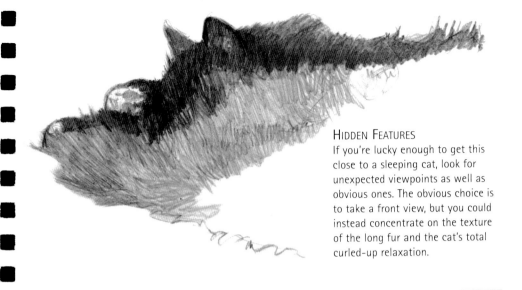

If you're lucky enough to get this close to a sleeping cat, look for unexpected viewpoints as well as obvious ones. The obvious choice is to take a front view, but you could instead concentrate on the texture of the long fur and the cat's total curled-up relaxation.

DRAWING A SLEEPING CAT

The combination of rigid-tipped marker pen and a contrasting, pliable brush pen allowed me to work quickly. The cat is in an elongated pose, and the contours are provided by the markings.

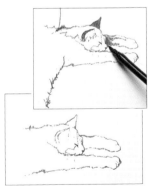

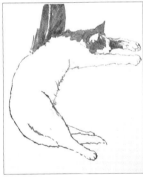

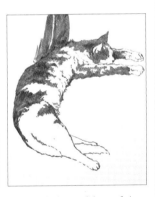

1 Using the marker pen, make fact-finding marks to establish the eyes and nose, then work outwards, including the stretched-out front legs. *Inset: Add some more rough outline down the body, then use the brush pen to block in some of the markings.*

2 Use the dark backdrop to define the shape of the shoulders and back with the brush pen, and add detail to the legs and paws. Make marks with the marker to capture the curves of the hind legs and tail, then turn your marks into an outline.

3 Mark the positions of the leg and body markings with the marker, then block them in using the brush pen – make sure the markings follow the contours of the body, and add the creases in the fur. You can add a contrasting colour in places for interest.

SITTING

When you observe a long-haired cat in a sitting position, you may have to remind yourself that this is the same animal who, when walking, running or stalking, is all muscles and sinew. As well as the added bulk on the ground, the fur of a cat when it is sitting can settle into a triangular shape that bears little resemblance to the standing cat. The difference is less marked in a short-haired cat, but it is still there.

The main things to look out for are the curve of the back, which often disguises the prominent shoulder blades, the position of the tail – curled round the feet or straight out – and the legs and feet: the front ones are usually neatly tucked together, and should be drawn as a unit.

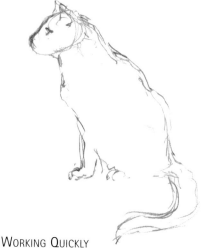

WORKING QUICKLY
It might take a bit of setting up, but if you can fix a cat's attention long enough, you can make sketches that build up a repertoire of sitting poses. You may have little time to go into details, so concentrate on using line markings to set the position.

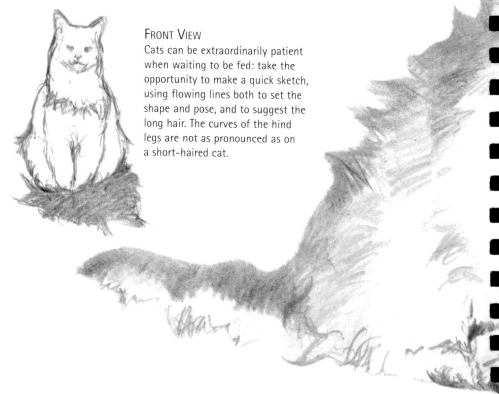

FRONT VIEW
Cats can be extraordinarily patient when waiting to be fed: take the opportunity to make a quick sketch, using flowing lines both to set the shape and pose, and to suggest the long hair. The curves of the hind legs are not as pronounced as on a short-haired cat.

Facing Two Ways

When a long-haired cat or kitten swivels its head round to look at something without getting up, the effect is similar to the way an owl can look through 180 degrees. The secret of success here is to really observe what you are drawing, and not to rely on making assumptions.

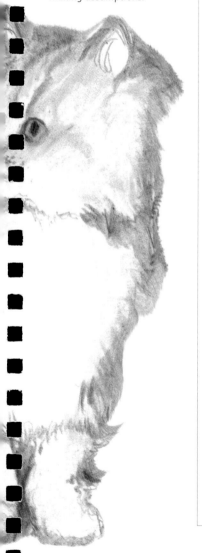

DRAWING A SITTING CAT

Each hair on a Somali cat has between three and twenty bands of colour; I used pastel and watercolour pencils to capture this. The pose combines a profiled body and full-on head.

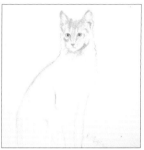

1 *Working outwards from the eyes and nose, find the sides and top of the head and the ears, using watercolour pencil. Inset: Look for equal distances – top of the ear, bottom of the chin and top of the leg crease – and use them to set the outlines.*

2 *Develop the front legs and the line of the back, sketching lightly. Add the colour for the eyes, using a sharp watercolour pencil; don't forget the black rims. Step back from the drawing at regular intervals, and make any necessary amendments.*

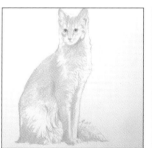

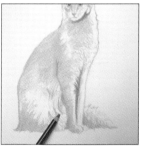

3 *Colour the nose, then use very light applications of yellow underlayer and orange-brown to create and develop a basic 'lilac' colour for the coat, defining the chin as you go and working downwards. Even in these first colours, look for where the shadows are.*

4 *Add more layers of colour, still working lightly and using the white of the paper for the highlights. Suggest shadows using the darker colours, and follow the direction of the fur. Pick out the darkest shadow areas with reds and grey-blue.*

Stretching and Scratching

No positions illustrate the suppleness and double-jointed qualities of cats better than those adopted when stretching and scratching, with washing poses (see page 80) a close second.

From being a roundish, small creature when sleeping or sitting, a cat can suddenly appear to be twice its length or height when stretching; even a short scratch of an ear can show the neck extended to odd lengths. This is where close observation is paramount: use your eyes, and don't follow what you think should be the case – however un-catlike or even hardly possible this may be. It's also worth grabbing the first drawing tool that comes to hand, as the practice you get in setting down the poses – however they turn out – is invaluable.

Balance and Tension
Although you can't see exactly what is happening, the whole pose of the body – the tilted head, the front legs bracing and pushing back, the arched back – says that the cat is scratching its right side with its hind leg. Look to capture the tension.

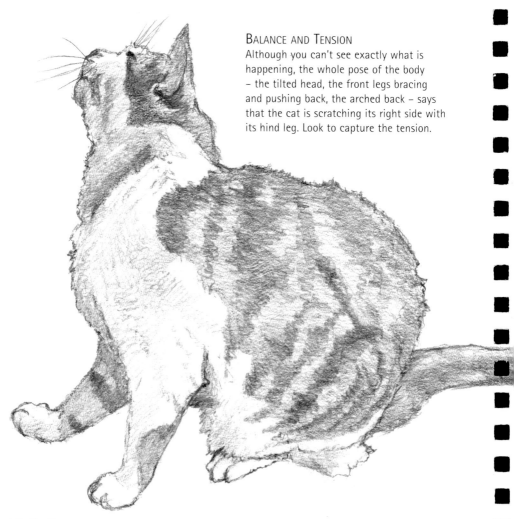

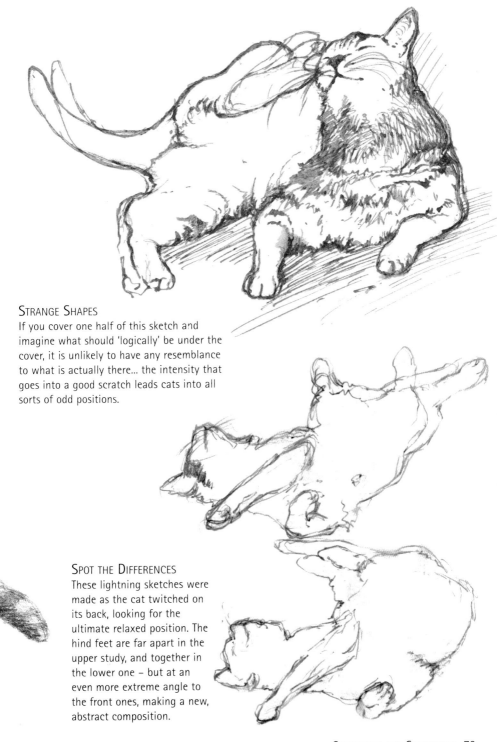

STRANGE SHAPES

If you cover one half of this sketch and imagine what should 'logically' be under the cover, it is unlikely to have any resemblance to what is actually there... the intensity that goes into a good scratch leads cats into all sorts of odd positions.

SPOT THE DIFFERENCES

These lightning sketches were made as the cat twitched on its back, looking for the ultimate relaxed position. The hind feet are far apart in the upper study, and together in the lower one – but at an even more extreme angle to the front ones, making a new, abstract composition.

Washing and Eating

Watching cats washing themselves invariably leads to the poses they adopt being described as 'balletic' – and so they are, when a hind leg is thrust straight up into the air or extended to its full length. But don't fall into the trap of trying to find balletic or graceful poses every time a cat starts grooming itself, as this can lead, more often than not, into parody or making inaccurate caricatures.

Washing poses are rarely held for long, but a hungry cat can spend a lot of time in the same position, giving you the opportunity to make both overall and close-up sketches and studies. Use quick media to build up a repertoire, and work up subsequent, more finished drawings at leisure.

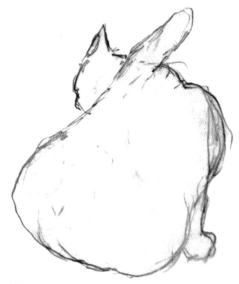

View from Behind
The shape made by this washing cat is far from that produced when the same animal is standing: in outline, there seems to be too much at the bottom end and at the right. However, this is what there really is before you add details and markings.

Watchful Eating
One of the vestiges of life in the wild that is still with domesticated cats is their habit of standing or crouching to eat, ready for action in case a predator or enemy attacks or tries to steal the food. Use a torchon stick to blend pencil markings on a dark Siamese.

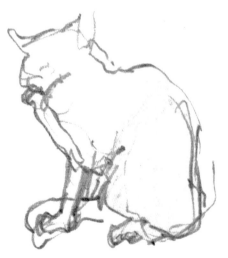

Quick Study
To capture a cat absorbed in cleaning, use as few pencil lines as possible to set down what you see. The effect is very angular, with the legs as the focus, aided by the almost vertical line of the lower back on the right.

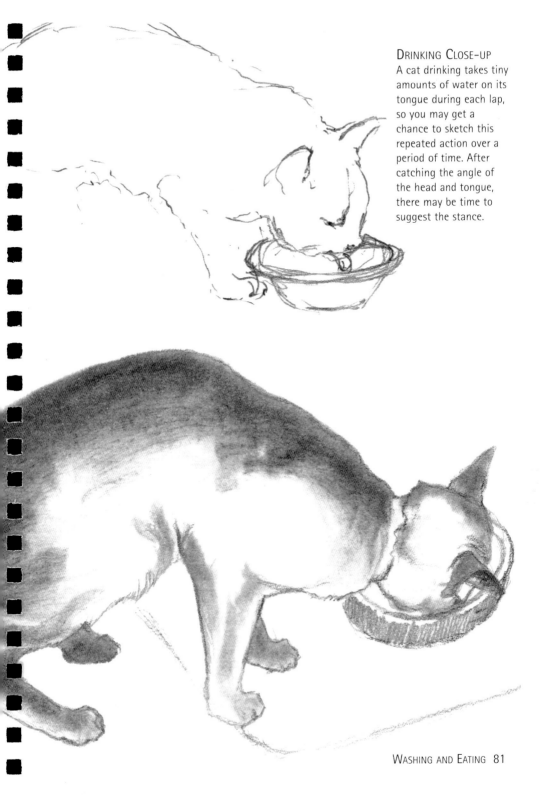

DRINKING CLOSE-UP
A cat drinking takes tiny amounts of water on its tongue during each lap, so you may get a chance to sketch this repeated action over a period of time. After catching the angle of the head and tongue, there may be time to suggest the stance.

PLAYING

'Mysterious little creatures, aren't they?' says a character with a cat on his lap in one of B. Kliban's *Cat* cartoons, while behind his head, four cats are turning somersaults and pulling faces on the couch back. The transformation from a dignified, elegant cat to a bundle of frenetic teeth and claws can be instantaneous, and is almost certainly a case for using reference photographs, ideally in combination with lightning sketches and studies.

Capturing cats at play also gives you the chance to involve another person in the drawing process – someone has to dangle the string or flick the silver-paper ball while you sketch the results. Look for angles and poses that you don't get in any other activity, and work up the results afterwards.

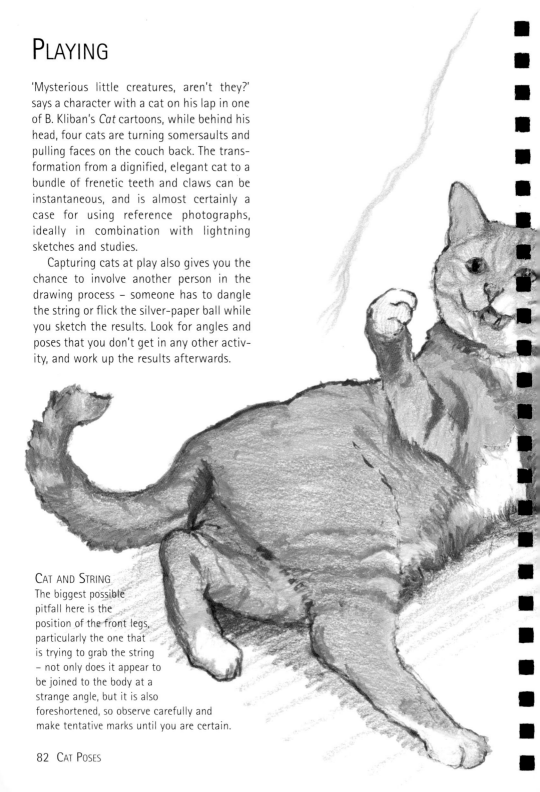

CAT AND STRING
The biggest possible pitfall here is the position of the front legs, particularly the one that is trying to grab the string – not only does it appear to be joined to the body at a strange angle, but it is also foreshortened, so observe carefully and make tentative marks until you are certain.

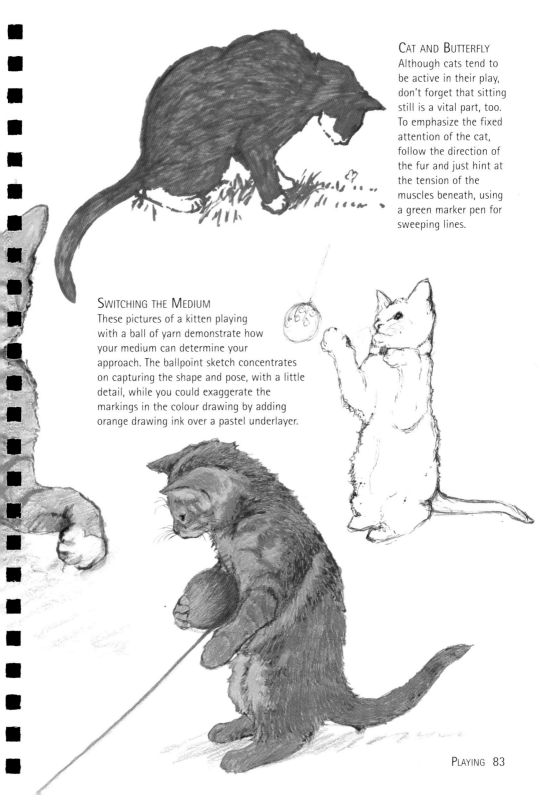

CAT AND BUTTERFLY

Although cats tend to be active in their play, don't forget that sitting still is a vital part, too. To emphasize the fixed attention of the cat, follow the direction of the fur and just hint at the tension of the muscles beneath, using a green marker pen for sweeping lines.

SWITCHING THE MEDIUM

These pictures of a kitten playing with a ball of yarn demonstrate how your medium can determine your approach. The ballpoint sketch concentrates on capturing the shape and pose, with a little detail, while you could exaggerate the markings in the colour drawing by adding orange drawing ink over a pastel underlayer.

WALKING AND RUNNING

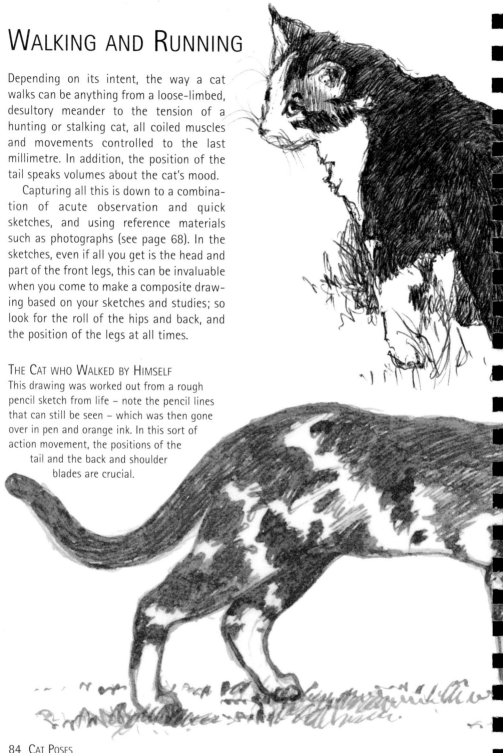

Depending on its intent, the way a cat walks can be anything from a loose-limbed, desultory meander to the tension of a hunting or stalking cat, all coiled muscles and movements controlled to the last millimetre. In addition, the position of the tail speaks volumes about the cat's mood.

Capturing all this is down to a combination of acute observation and quick sketches, and using reference materials such as photographs (see page 68). In the sketches, even if all you get is the head and part of the front legs, this can be invaluable when you come to make a composite drawing based on your sketches and studies; so look for the roll of the hips and back, and the position of the legs at all times.

THE CAT WHO WALKED BY HIMSELF
This drawing was worked out from a rough pencil sketch from life – note the pencil lines that can still be seen – which was then gone over in pen and orange ink. In this sort of action movement, the positions of the tail and the back and shoulder blades are crucial.

REAR VIEW

Seen from this angle, there is little information about the positioning of the legs and feet: only one hind leg can be seen, and even that is partially obscured by grass. Instead, the direction of the fur and contours of the body give the clues to follow.

DRAWING A STALKING CAT

I used soft monochrome media – HB and 2B graphite sticks, graphite powder and torchon – to suggest the body tension and control in this side-on view of a stalking grey cat.

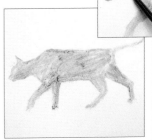

1 *Dip the torchon into the graphite powder and draw the head and ears, at the same time establishing the shape and providing some shading and blocking in. Even at this early stage, look to shape the contours of the muscles, and check the proportions.*

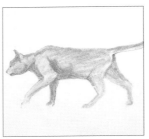

2 *Continue to draw the whole body in the same way, looking carefully at the shoulder blades and tail. The hind feet must be in contact with the ground, and the legs must show tension. Inset: Use the HB graphite stick to define the head and face.*

3 *If you want to use fixative here, blow the dust off first. Using the torchon and HB graphite stick alternately, suggest the shadows cast by a low light source to the left. Then strengthen the pose with the 2B graphite stick, emphasizing the contour lines.*

4 *Cut small wedges from a plastic eraser, then use them to pull the graphite off the paper and create highlights and markings. If required, go back to the white paper and mark in again carefully. Pull out the muscle shapes through the fur.*

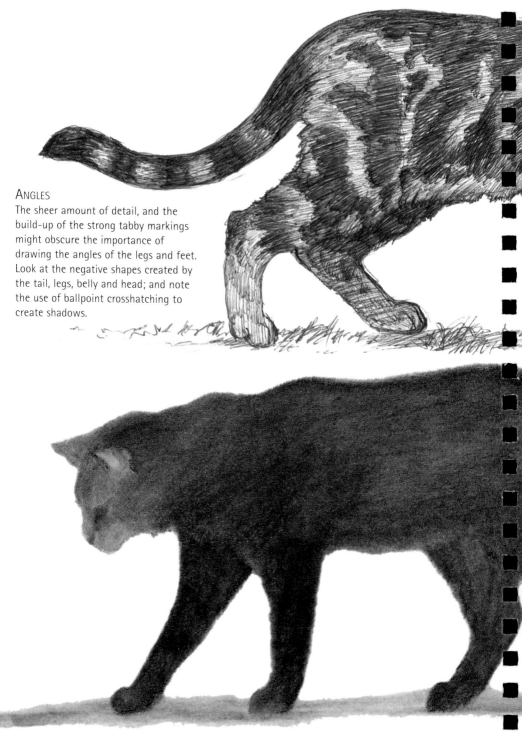

ANGLES

The sheer amount of detail, and the build-up of the strong tabby markings might obscure the importance of drawing the angles of the legs and feet. Look at the negative shapes created by the tail, legs, belly and head; and note the use of ballpoint crosshatching to create shadows.

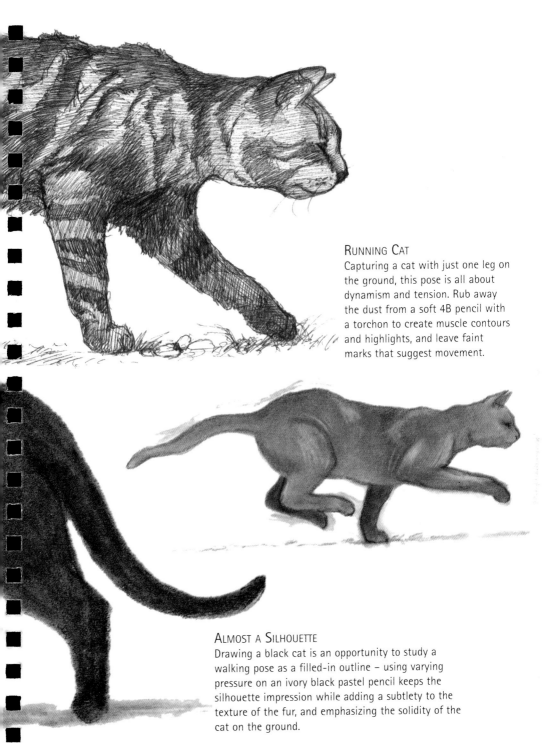

RUNNING CAT
Capturing a cat with just one leg on the ground, this pose is all about dynamism and tension. Rub away the dust from a soft 4B pencil with a torchon to create muscle contours and highlights, and leave faint marks that suggest movement.

ALMOST A SILHOUETTE
Drawing a black cat is an opportunity to study a walking pose as a filled-in outline – using varying pressure on an ivory black pastel pencil keeps the silhouette impression while adding a subtlety to the texture of the fur, and emphasizing the solidity of the cat on the ground.

JUMPING

If anything encapsulates feline grace and strength, it's the sight of a cat weighing up a distance, steadying itself and then launching into a great leap, landing safely and accurately on what is often a tiny space. And because this whole action can be over in a second or two, jumping is nigh-on impossible to capture in a drawing without the use of photographic reference (see page 68).

Another good way to study a jumping cat is to film it using a video camera: you can then freeze frames at any part of the leap, and use a computer to isolate single moments. Once again, none of this will help you to produce effective drawings unless it is backed up by observation and, in this case, very rough sketches of the motion.

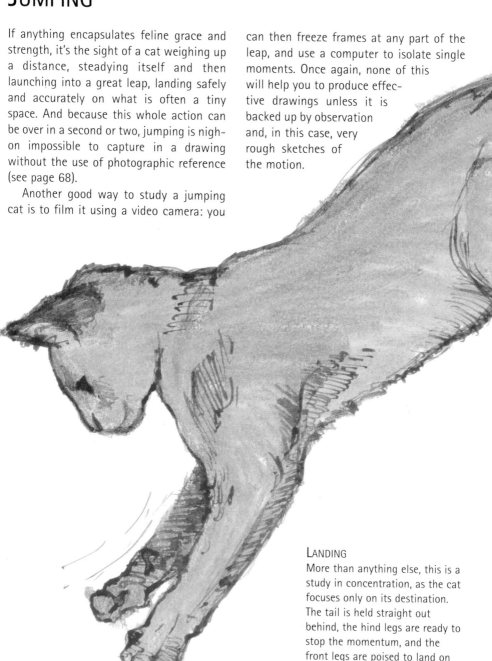

LANDING
More than anything else, this is a study in concentration, as the cat focuses only on its destination. The tail is held straight out behind, the hind legs are ready to stop the momentum, and the front legs are poised to land on exactly the right spot.

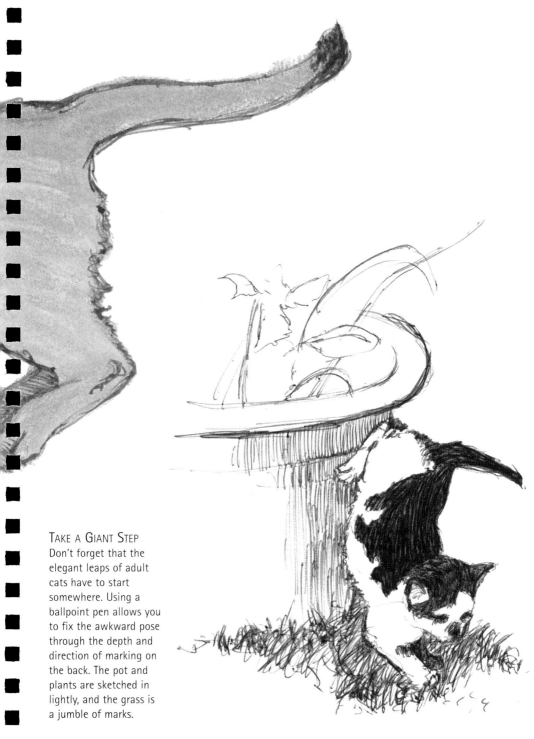

TAKE A GIANT STEP
Don't forget that the elegant leaps of adult cats have to start somewhere. Using a ballpoint pen allows you to fix the awkward pose through the depth and direction of marking on the back. The pot and plants are sketched in lightly, and the grass is a jumble of marks.

CATS TOGETHER

The interaction between cats is intriguing: the change from helpless, totally dependent kittens to rough-and-tumbling young cats is a quick transformation; and the harmony and intermingling of two cats who are friends is at complete odds with the long, elaborate stand-offs and short flurries of teeth and claws that mark the establishing of territory.

This is, of course, all grist to the artist's mill, and it is worth seeking out places where you can observe and sketch groups or at least couples of cats. Working farms are a good place to start – sometimes there may be more cats than you bargained for! – as are cat rescue centres and breeders of pedigree cats. Look for similarities and contrasts, and experiment with different media within one drawing.

MOTHER AND KITTENS
Once kittens are old enough to explore independently, but still suckle, you can capture some delightful poses that are studies in opposites: the spiky fur, short legs and stubby tails of the kittens contrast with the smooth fur and long (but foreshortened) legs and tail of the mother.

ROUGH AND TUMBLE
Play-fighting sometimes gives you the chance to include cats' undersides, which you don't often get to see: the markings on this recumbent kitten's belly contrast with its tiger-stripe back and are a study in themselves. The sweep of the fur on the standing kitten emphasizes the dynamism of its pose.

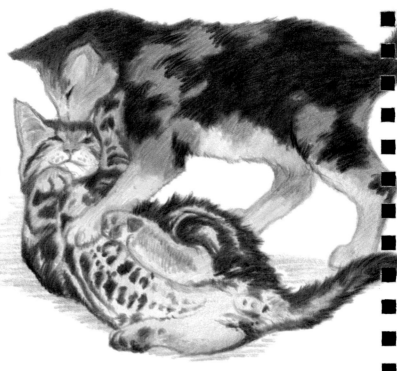

DRAWING TWO CATS

Cats intertwined or in a bundle are always appealing. I used mixed media – pencils, crayons, watercolour pencils, graphite – to establish the colouring and markings, and pen and inks to unify the picture.

1 Use an HB pencil to lightly establish the lower face, moving outwards and right to take in the leg and negative shape of the upper cat's leg. *Inset: Light guide lines can help in setting the eye/nose triangle for the upper cat along the lower cat's back.*

2 Fix the outlines of the lower cat's body first, then move across the composition, always checking as you go – and establish the upper body in the same way. Use the negative shapes around both cats to fix the dimensions, proportions and relationships.

3 Use waxy watercolour pencils to colour in the lower cat's eyes and nose; this also provides a base against which to judge the yellow underlayer across the body. Colour the ears and mouth, start to cover the body, and set the markings with raw sienna.

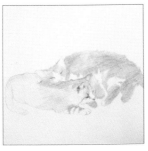

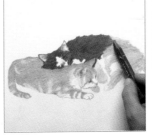

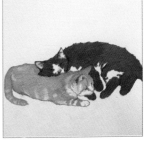

4 After adding the orange to the lower cat, move to the upper cat, establishing the markings with an HB pencil. Then use a torchon dipped in graphite powder to block in the dark areas, working loosely and freely, and following the contours of the body.

5 Deepen the lower cat's overall colour with water-colour pencils and then orange wax crayons. Moving to the upper cat, use a graphite stick to darken the black areas, paying attention to the spiky fur along the back. Colour in the upper cat's nose and ears.

6 To accentuate the darkest details and creases on the lower cat, use pen and red-brown ink, and marker pen to strengthen the orange, leaving the underlayers visible. Use black ink to do the same on the upper cat – working care-fully where the cats' fur meets.

Kittens

The first chapter gave a glimpse of some of the physical and proportional differences between cats and kittens, and suggested what, in theoretical terms, to look out for. When it comes to putting this into practice, however, you are far less likely to be able to set down any poses, other than sleeping ones, at the beginning – kittens are constantly on the go, and even when they manage to sit still they appear to be vibrating and twitching!

Use photographs to capture poses (see page 68), but don't be tempted to rely just upon them; it is only by lots of direct observation – hardly a problem with playful, inquisitive kittens – that you can understand just how the barrel-shape body and stumbling, undeveloped legs can produce such activity.

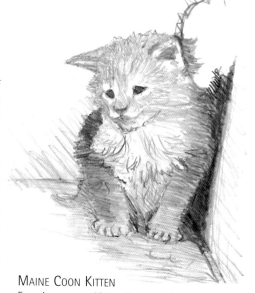

Maine Coon Kitten
Even in a young kitten the size of the paws shows that this will be a big cat. Seize any opportunity to draw while a kitten is stationary, and concentrate on capturing the head, ears and long chest ruff. Use scribbled lines to place the rump and tail.

Stretching Out
This could be called a classic kitten pose, with the oversize head, long, straggly fur, short legs and stumpy tail all present and correct. The low side-lighting source places the face and front legs into the foreground, and the white-paper highlights contrast with the dark shadowed areas behind.

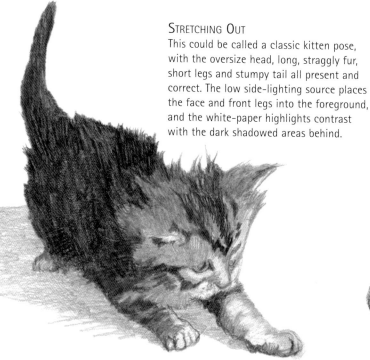

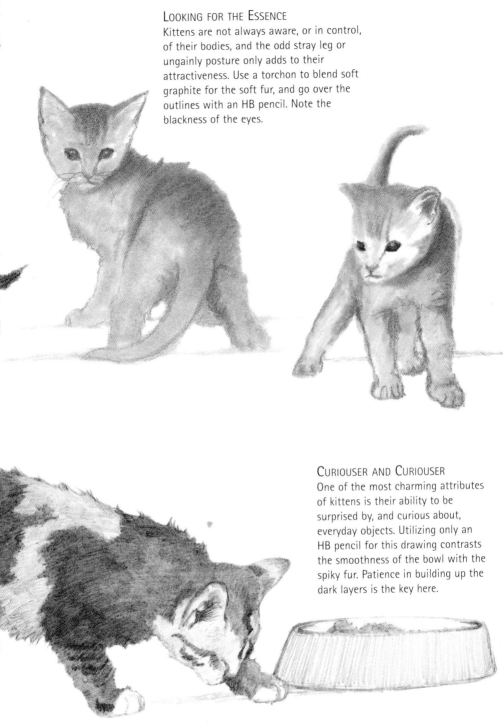

LOOKING FOR THE ESSENCE
Kittens are not always aware, or in control, of their bodies, and the odd stray leg or ungainly posture only adds to their attractiveness. Use a torchon to blend soft graphite for the soft fur, and go over the outlines with an HB pencil. Note the blackness of the eyes.

CURIOUSER AND CURIOUSER
One of the most charming attributes of kittens is their ability to be surprised by, and curious about, everyday objects. Utilizing only an HB pencil for this drawing contrasts the smoothness of the bowl with the spiky fur. Patience in building up the dark layers is the key here.

INDEX

ACKNOWLEDGEMENTS

I would like to thank my wife, Glynis, for her patience and enthusiasm when my time drawing has meant less time together; Pauline Wiseman at Waltham Cattery, Grimsby; Colin and Erika Turner Gale; Lynne Robinson Syres; Andrew Robinson Syres; Sue and Mike Smith; Madeline Slater, Maine Coon breeder at Ashby cum Fenby, Lincolnshire; Ian Kearey, my friend and editor, for his professionalism and enthusiasm, and the staff at Collins & Brown for their help and interest in the preparation of this book.

The publishers wish to thank George Taylor and Sarah Hickey for the enjoyable photo sessions; Gemma Davies, Katie Hardwicke and Minnie, Stephen and Emma Ferguson and Thisbe, Caroline Halcrow and Geronimo.